STEP-BY-STEP

Art School

LANDSCAPES

STEP-BY-STEP

Art School

LANDSCAPES

JACK BUCHAN AND JONATHAN BAKER

**CHARTWELL
BOOKS, INC.**

For copyright reasons this edition is
for sale only within the USA.

This edition published in 1993 by
Chartwell Books, Inc.
A division of Book Sales, Inc.
110 Enterprise Avenue
Secaucus, New Jersey 07094

First published by Reed Consumer Books Limited.
Michelin House, 81 Fulham Road, London SW3 6RB

Copyright © Reed International Books Limited 1993

ISBN 1 55521 828 8

Produced, designed and typeset by
Blackjacks
30 Windsor Road
London W5 5PD

Colour origination by Regent in Hong Kong
Text origination by Manuscript, UK
Printed in Hong Kong

For Blackjacks:
Artwork & demonstrations for:
Country Lane, Four Trees, Greek Valley,
Swiss Alps & Waterfall – Roy Ellsworth;
New York's Central Park, Fields of Tuscany,
Coast of Normandy, Sunset & White Horse – Ian Sidaway
Photography by Paul Forrester
Additional photography by Chas Wilder
Edited by Angie Gair

Credits
Front cover main photograph Ian Sidaway; pp2-3 National Gallery, London; pp10-11 National
Gallery, London; p12 *top* Alte Pinakothek, Munich, Bridgeman Art Library Ltd, London; *bottom*
The National Trust Photographic Library, London; p13 Galleria dell'Accademia, Venice,
Bridgeman Art Library Ltd; p14 National Gallery, London; p15 *top* Tate Gallery, London,
Bridgeman Art Library Ltd; *bottom* Louvre, Paris, Bridgeman Art Library Ltd/Giraudon; p16 *top*
Hermitage, St Petersurg; *bottom* Tate Gallery, London, Bridgeman Art Library Ltd; p17 *top* Musée
d'Orsay, Paris, Bridgeman Art Library Ltd/Giraudon; *bottom* National Gallery, London; p18 *left*
Gemaldegalerie, Dresden, Bridgeman Art Library Ltd; *right* Christies, London, Bridgeman Art
Library Ltd, courtesy of Paul Nash Trust; p19 *top* Sally Hargreaves; *left* H.R. Giger; *right* Museum
of Modern Art, New York, Bridgeman Art Library Ltd, © DEMART PRO ARTE BV/DACS,
London 1993; *bottom right* Private Collection, Bridgeman Art Library Ltd, © ADAGP, Paris and
DACS, London 1993; pp20-1 & p27 Roy Ellsworth; pp28-29 all reference photographs supplied by
Ian Sidaway and Roy Ellsworth; pp142-3 Museum of Modern Art, New York, Bridgeman Art
Library, © DEMART PRO ARTE BV/DACS, London 1993.

Every effort has been made to contact all copyright holders of illustrations used in this book. If
there are any omissions, we apologize in advance.

Special thanks to Paul Gates of Kodak for supplying the photographic film.

Contents

Chapter 1	**Introduction**	10
Chapter 2	**Where to Start**	20
	Choosing your Subject	22
	At Home or Outdoors?	24
	Composing your Picture	26
	Perspective	27
	Photographic Reference	28
Chapter 3	**Without Colour**	30
	Materials	32
	Techniques	34
	Country Lane	38
	New York's Central Park	46
Chapter 4	**Dry Colour**	52
	Materials	54
	Techniques	56
	Four Trees	62
	Fields of Tuscany	68
Chapter 5	**Watercolour**	76
	Materials	78
	Techniques	80
	Coast of Normandy	82
	Greek Valley	88
Chapter 6	**Acrylics**	98
	Materials	100
	Techniques	102
	Sunset	106
	Swiss Alps	112
Chapter 7	**Oils**	120
	Materials	122
	Techniques	124
	White Horse	126
	Waterfall	134
	Index	140

Chapter 1
Introduction

Landscapes are without a doubt one of the most popular subjects for painting in the world. This is hardly surprising, because, after all, painting is all about what we see, and we are surrounded by some form of landscape every day of our lives. It is through man's natural curiosity with the world around him that landscape painting was born. Although it is easy to trace the roots of landscape painting back through history, surprisingly it only evolved into a pure art form in its own right in the past few hundred years. When you think about it, this is pretty incredible given the fact that man has expressed himself through paintings in one form or another since his time on earth began.

The birth of real landscape painting was indeed down to mother nature herself, since once artists were freed from the constraints of only depicting stories – mainly of a religious kind – the heavy Christian symbolism which the Church had demanded immediately gave way to a more natural realism.

When planning this book difficult decisions concerning the definition of landscape painting had to be made. After all, these days our 'natural' environment is of concrete and our 'hills' are skyscrapers. So, out of much debating, came the decision to concentrate on the traditional style of the natural landscape, but at the same time show you how to interpret it in many different ways.

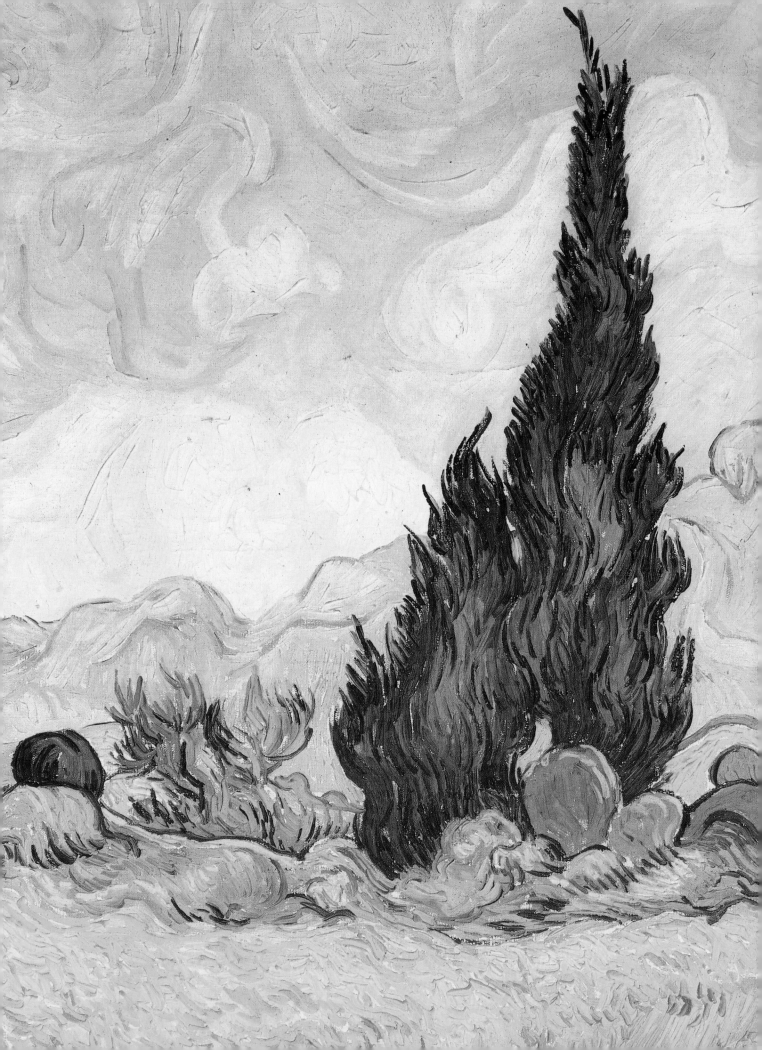

Introduction

HISTORY

Although we can trace the first evidence of elements of landscape painting back to the caves of prehistoric man and throughout great historic periods from ancient Greece and Rome to the Chinese T'ang dynasty, we have decided to use the limited space in this book to concentrate on a history that will be relevant to landscape painting as we think of it today. Having said this we really cannot begin without mentioning that landscapes appeared throughout the Middle Ages but the Christian church was extremely powerful, and dictated that landscape elements should be used purely as backdrops to religious scenes and characters. Therefore landscapes were mainly symbolic and decorative

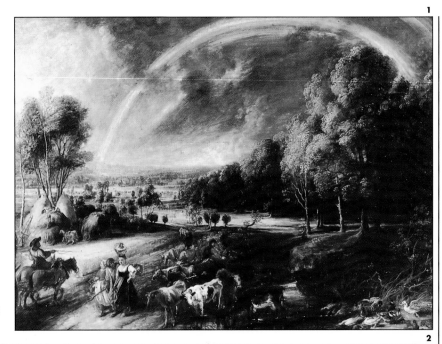

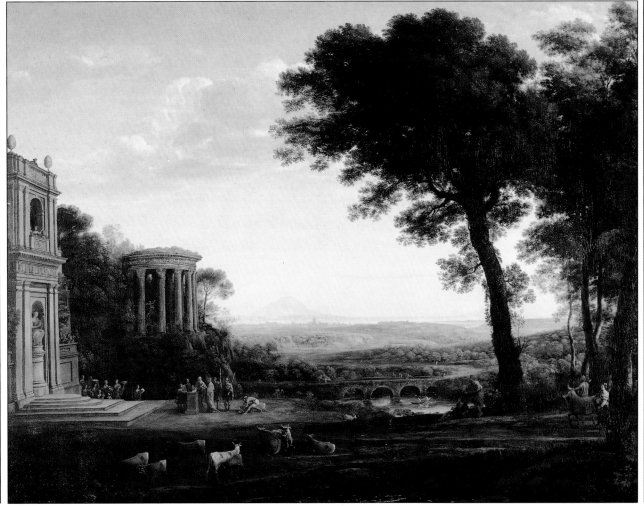

12

elements that bore no relevance to reality. In the early part of the fifteenth century miniatures became very popular and were used to illustrate manuscripts called 'Books of Hours', which were originally intended for private devotion. The most famous example of these was a series of 12 calendar scenes painted by the Limburg brothers and commissioned by the brother of Charles V of France. Some of these exquisite illustrations included landscapes which are considered to be the first realistic renditions of the subject in northern European art.

As far as the first real landscape is concerned, the main opinion is that it was a painting rendered by the Venetian artist Giorgione [1478-1510] called 'The Tempest'. He was certainly one of the first in a new school of thought characterized by painters who used their imagination and natural creativity – a change from the old school, where artists were considered only as illustrators (mainly restricted to religious themes) or copyists. Giorgione's influences were formed by a very important movement which lasted from the fourteenth to the sixteenth century, known as the Renaissance period. The word Renaissance means 'rebirth', and this era witnessed an extraordinary upheaval of ideas on science, philosophy and the visual arts. The Church was no longer all-powerful, and man became 'the centre of all things'. The stylized concepts of mediaeval art were now rejected, and artists were free to produce accurate and naturalistic paintings of figures and landscapes. Leonardo da Vinci [1452-1519] in his work 'Treatise on Painting' urged artists to be inventive and to study such things as clouds and light, as well as rocks and fire, and to use these natural elements as they saw them. This was a further bid for artists to be respected on a similar level to intellectual creators such as

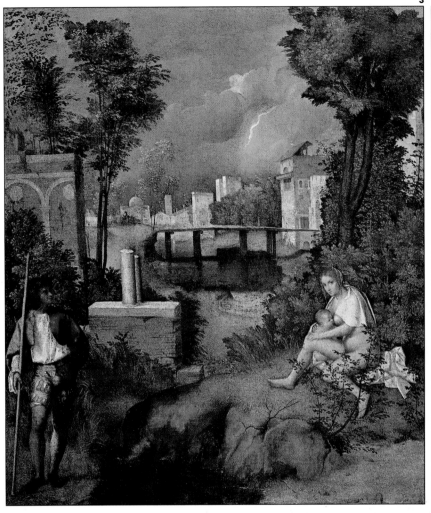

writers. Bare in mind that Leonardo himself was also intensely interested in the science of nature and would spend days rendering the natural elements that surrounded him, such as plants and rock formations.

Although Leonardo might be the most famous instigator of this new movement towards reality, he cannot take the credit for the discovery of linear perspective. This developed as a result of the new, more scientific approach to art and was perfected through a system of mathematics. One of the first masters of perspective was Piero della Francesca [c 1410-1492] who also wrote a book on the subject.

Giovanni Bellini [c 1430-1516] was Giorgione's master and although his works were mainly figurative, his

1 *'The Rainbow Landscape'.*
Peter Paul Rubens.
Although Rubens is not normally associated with landscape painting, he still produced some memorable examples which illustrate his incredible skill with colour.

2 *'The Father of Psyche Sacrificing at the Temple of Apollo'. Claude Lorraine, 1663.*
Even though Claude's landscapes were of purely imaginary scenes, all the natural elements were based on the sketches he made.

3 *'The Tempest'. Giorgione.*
This painting is still considered to be the first real landscape.

backgrounds contained natural landscapes which showed his great sense of proportion and love of light. It was these skills which he passed on to Giorgione, who employed them in his quest for the ideal landscape. A young contemporary of Giorgione's was the artist Titian [*c* 1487-1576] and although figures played a major role in his paintings, his atmospheric landscape backgrounds, with their clumpy trees and misty blue hills, have played a major role in influencing landscape painters throughout the ages.

Italy was still considered the centre of the Renaissance movement, but the growth of transport made long-distance travel easier, and therefore artists from all over Europe were able to travel to Italy to study, returning to their native countries with this new train of thought.

Another important historical factor which influenced the growth of landscape painting was the beginning of the Reformation period. Flemish artists who had previously been restricted to religious themes were now able to explore new fields of painting. All these influences reached artists such as Pieter Bruegel the Elder [*c* 1525-1569] who is usually remembered for his scenes of peasant life, but who took to painting large-scale landscapes in oils during the last five years of his life. These paintings elevated landscape painting to new heights and certainly paved the way for the Dutch Masters of the seventeenth century. Joachim Patenier [*d c* 1524] was the first artist to allow the landscape to dominate all the other elements in a vast panoramic landscape. Albrecht Altdorfer [*c* 1485-1538] was another example of a painter who took to painting pure landscapes in his later life.

During the seventeenth century landscape became the dominant theme of painting in both northern and southern Europe. The French painter

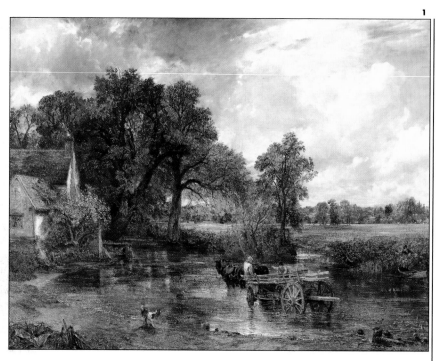

Claude [1600-1682], often referred to as Claude Lorraine as this is where he was born, moved to Rome at the age of 12 and remained there for most of his life. His paintings are still considered to be the most picturesque ever rendered, featuring gracefully posed figures set in a classical landscape bathed in a soft golden light. He would sketch relentlessly in Campagna, the countryside surrounding Rome, making studies of the varying light of sunsets and sunrises and filling sketch books with detailed drawings of trees, lakes and mountains. He would then return to his studio and compose landscapes from his imagination but based on the individual forms that he had seen in his beloved countryside. This way he created idealized landscapes that projected a great feeling of serenity. His landscapes made such an impact that even a hundred years after his death, realistic landscapes were judged on the standards which he had set. Claude was also to have a huge influence on English painters in the eighteenth century, notably Joseph Mallord William Turner [1775-1881].

Another painter of great note who was in Rome at the same time as Claude was Nicolas Poussin [1594-1665]. His landscapes were just as beautiful as Claude's but they were more intellectual in approach and usually based on themes from ancient mythology and religion. He did not start to paint landscapes until 1648, when he was already 54, and it is said that where Claude achieved balance by instinct, Poussin measured it with a ruler. However, Poussin was an equally important influence on landscape painters. He was obsessed with geometry and would plot his landscapes using horizontals and verticals and paying serious attention to the rules of the golden section. His genius lay in being able to disguise this scientific approach, creating works of great rhythm and balance.

In Holland, during the seventeenth century, painting had never been so popular. After the war with Spain the country was now an independent republic, and it was the rich merchants and burghers, not royalty, who had huge wealth. With their money they built fine houses and

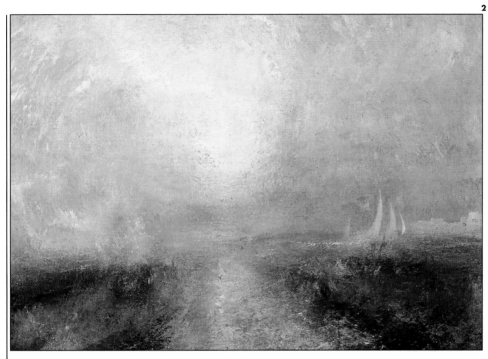

1 *'The Hay Wain'. John Constable, 1821.* This is certainly Constable's most famous painting. Although he was meticulous about detail, this painting was done in his London studio from sketches.

2 *'Yacht Approaching the Coast'. Joseph Mallord William Turner.* When Turner died he left behind him over 20,000 paintings – the 'perils of the sea' being the most widely repeated theme.

3 *'Cliffs at Etertat after the Storm'. Gustave Courbet, 1869.* This scene also attracted the attention of one of our artists – as you can see with the step-by-step project which starts on page 82.

commissioned artists to paint landscapes, portraits, still lifes and interior scenes to hang on the walls. Landscapes depicting scenes of the native Dutch countryside became especially popular, and from this new trend such great painters as Meindert Hobbema [1638-1709], Jacob van Ruisdael [1628-1682] and Philips de Koninck [1619-1688] emerged, all producing superb examples of natural and realistic landscapes. The painter Peter Paul Rubens [1577-1640], who although is not really remembered for being a landscape painter, nevertheless produced some amazing landscapes including the remarkable 'Rainbow Landscape' which uses colour so ingeniously that it defies anyone to fault it. We must also include Rembrandt van Rijn [1606-1669] who produced such masters as 'Stormy Landscape' which illustrates his strong handling of light and shade.

The eighteenth century Rococo taste initiated the return to a more decorative style of painting which became apparent in the works of Watteau [1684-1721] of France and Thomas Gainsborough [1727-1788] in

England. However, the latter half of the century saw the emergence of two of the greatest English landscape artists, Turner and John Constable [1776-1837], who rejected picturesque idealized landscapes and looked to the Dutch realists, Hobbema and Ruisdael for their inspiration. Although their styles were very different these artists raised landscape painting to new heights and helped make one of the most important contributions to classical art that England has made.

Turner's greatest hero was Claude and when he left his paintings to the nation it was on the condition that one of his paintings must always hang next to a work by Claude. Even so the two styles are very different, Claude with his dreamy, serene landscapes of an idealized world, and Turner whose paintings depict the overwhelming forces of nature. He loved the drama of storms and tempests, and some of his best works fuse all the natural elements of sky,

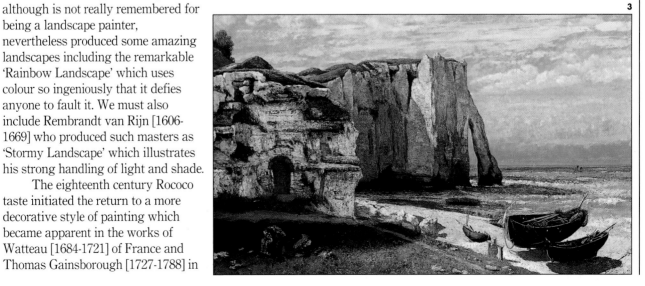

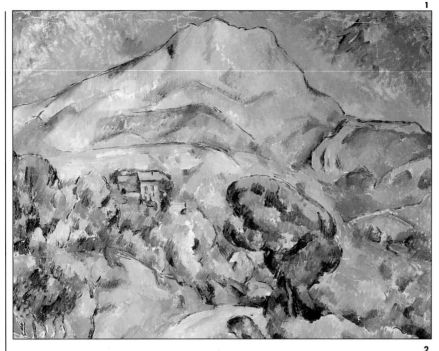

sea, clouds, wind and light into a catharsis of colour.

Constable, on the other hand was a naturalist and while Turner painted wild seas, Constable painted rivers. He held great respect for other artists but he was not interested in their theories, he just wanted to paint what he saw in an honest way as a homage to nature.

In France there was another group of artists also concerned with painting their native countryside. These included Corot [1796-1875] whose style was a mix of classicism and natural observation, and Gustave Courbet [1819-1877] who employed a more direct approach, often employing crude colour with realistic form. Later that century, in France, one of the most important and influential schools of painting was born – Impressionism. This period was a kind of second Renaissance, a time of social and political upheaval, scientific discovery and economic expansion. Accordingly, artists began to reject the staid traditions of the art academies in favour of a more naturalistic view of the world. The Impressionists' daring use of colour, their 'snapshot' compositions and their delight in the ordinary as opposed to the idealized, was to revolutionize painting forever. There were so many painters to come out of this school that it would be impossible to name them all, but certainly Claude Monet [1840-1926] was one of the greatest along with Camille Pissarro [1831-1903], Alfred Sisley [1839-1899], Renoir [1841-1919] and Paul Cézanne [1839-1906]. Their main aim was to paint straight from nature, so their interests were in light and colour and a technique which represented their visual sensations. They always painted outdoors, using rapid, spontaneous brushstrokes applied in small strokes and dabs to capture the fleeting effects of the natural light.

1 *'Mont Sainte-Victoire'. Paul Cézanne, c 1904-06.* This mountain near Cézanne's home in Provence was an obsession – he painted it repeatedly.

2 *'The Bec du Hoc, Grandcamp'. Georges Seurat, 1885.* Seurat's compositions always radiate a wonderful sense of peace and calmness.

3 *'The Seine at Argenteuil' (detail). Claude Monet, 1873.* Monet's obsession was much more with light than the subject.

4 *'Cornfield and Cypresses'. Vincent Van Gogh, 1889.* This scene was painted after Van Gogh's admission to a mental asylum.

The Impressionists all had their own firm, independent ideas and never actually painted as a group but went their separate ways. Monet became obsessed with light and in his later paintings the subject itself became subordinate to the effects of colour and light which played upon it. Renoir and Pissarro did paint together and they developed the use of bright colours applied in small flecks and dabs that we all associate with the Impressionists. Sisley on the other hand was slightly more conservative and stuck to a more realistic style. Cézanne seemed to yearn for something more, eventually rejecting Impressionism in his quest to find the solidity and structure underlying natural forms. His resulting landscapes can almost be described as 'natural' still lifes.

Before entering the twentieth century there are two other artists to whom we must pay homage: Georges Seurat [1859-1891] and Vincent van Gogh [1853-1890]. Seurat was fanatical about colour and approached it through a scientific route. He studied the colour theories of scientists such as Chevreul and Goethe as well as scientific papers on visual phenomena and the nature of light. From these he evolved a style of painting known as pointillism, in which the painting's surface is made up of tiny dots of pure colour. His paintings are without a doubt brilliant and all the colour 'mixes' within them take place in the viewer's brain.

Van Gogh took to painting late in life. He went to Paris to absorb some of the teachings of the Impressionists before moving to Arles where he painted unceasingly until he committed suicide at the age of 37. He is without doubt one of the most original painters – as well as being very prolific – during the years that he painted, he did over 800 canvases.

Landscape painting in the twentieth century has really ceased to exist in the traditional sense of the word. There are no longer specific styles or schools of thought so there are no restrictions. The landscapes of the twentieth century express the

3

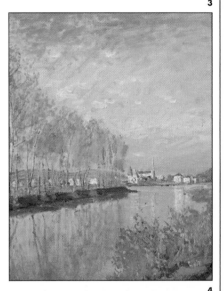

4

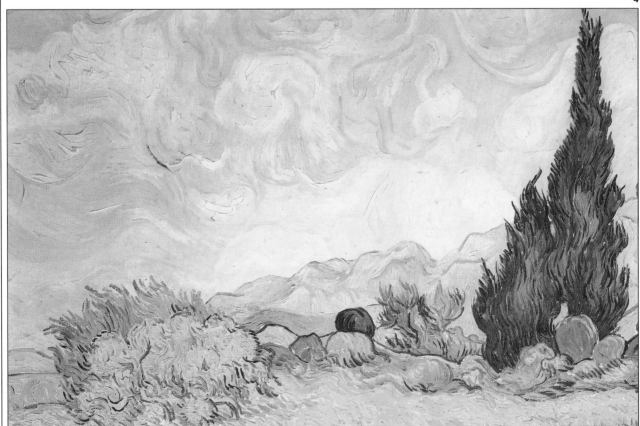

environment in which we live. To some extent we have lost touch with nature; we live in an increasingly man-made and false environment so it is hardly surprising that this is reflected in modern paintings. Contemporary landscapes are more a psychological than realistic interpretation of that world. Modern landscape styles are so diverse that it is impossible to summarize them in words, so we have instead chosen a representative selection of pictures to illustrate this diversity. Even if these are not all to your taste we hope that by comparing them to the early examples you can see how landscape painting has evolved. The question is, what will be next? Perhaps with our renewed interest in the environment and a more natural way of living, landscapes will eventually come full circle and revert once again to representing the beauty that nature has to offer.

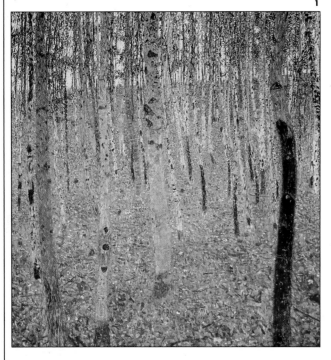

1

2

1 *'Beech Forest'. Gustav Klimt.* In his later years Klimt would often paint landscapes. His style was closer to the Neo-Impressionists and Pointillists with his use of fine, small brush strokes.

2 *'March Woods, Whiteleaf, Berkshire'. Paul Nash.* Nash was part of a school of painting in the twentieth century known as Nationalists. They were patriotic, and their aim was to show the natural beauty of their own country.

3 *'Summer Light'. Sally Hargreaves.* Although this painting minimizes detail, it still creates a feeling of harmony, allowing the natural beauty of the light of summer to come across.

4 *'Cataract'. H R Giger, 1977.* Giger is not normally thought of as a landscape painter, but as the artist who created the sets and the 'beast' for the film *Alien*. His work as a visionary artist is hailed worldwide, and however weird this painting may seem, it throws open a completely different dimension to landscape painting as we know it.

5 *'The Persistence of Memory'. Salvador Dali, 1931.* Dali will always be thought of as the king of surrealism, but it is interesting to note how his landscapes were very true to life – as in the cliffs and sky. The element of shock comes through the placing of incongruous objects.

6 *'The Human Condition'. Rene Magritte, 1933.* Classed as a surrealist painter, Magritte enjoyed expressing himself with this new style of freedom. This example takes the traditional style of landscape – often referred to as a 'window on the world' – one step further!

Chapter 2
Where to Start

Before you start to paint or draw a landscape there are two major steps that you must first take: choosing your subject and then composing your picture. This may seem blatantly obvious, but lack of thought at either of these stages could easily result in a picture which has no direction and just cannot be saved.

Working indoors from photographic reference will of course overcome a lot of problems as, to some degree, you have already selected your subject matter.

The idea of working *en plein air* appeals to most landscape painters, but until you give it a go you will not understand how difficult this can be. Unless you have a good idea of what you want to paint, you will most probably spend the whole day roaming around the countryside waiting for inspiration or luck to hit you. Once you do find a spot to sit yourself down you will be struck by just how vast a landscape can be. The horizon will probably be miles from you, with a huge expanse of land stretching out towards it, dotted with trees, rivers, fields bushes and quite simply a massive variety of shapes, colours and textures. To top this all off there is the great dome of the sky above you to contend with. For the beginner – and sometimes even for the professional – it comes down to a basic question of "where do I start?" In this chapter we hope to set you off in the right direction.

Where to Start

CHOOSING YOUR SUBJECT

If a group of six artists sat down in a field together to paint a landscape each, then you can be pretty sure that you will end up with six completely different landscapes. There is no 'perfect' landscape to draw or paint – and it is best to ignore other people's suggestions of a 'good spot'. When it comes down to it you should use your own judgement to select a scene which you feel will work best for you.

A great deal depends on your own interests. Most landscape painters have a deep love for the countryside, but there the similarity often ends. Some are fascinated by the movement of clouds across the great expanse of the sky, others may find the play of light on a simple object such as a haystack more intriguing. Everyone is different and each has his or her own tastes. Even if two people have exactly the same interests, their pictures will be different. A great deal depends on the medium you prefer to work in, even more hangs on the kind of person you are. The careful type would spend much time selecting a scene, doing test sketches and so forth to make sure everything was perfect before actually starting work. A more impulsive type would probably just sit down at the first good spot and get on with it. Neither way is right or wrong. Different styles and ways of working suit different people.

For the novice landscape artist, the best place to start is by concentrating on an aspect of the

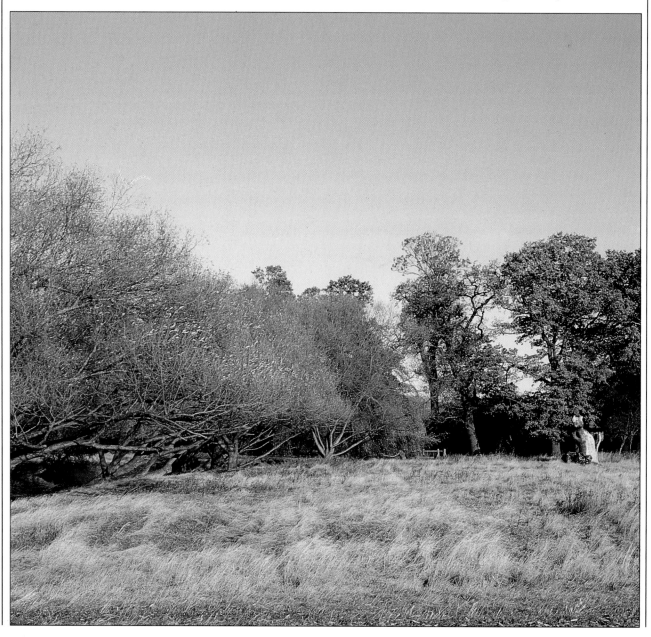

natural world which you enjoy or by selecting scenes which you find especially attractive or meaningful. Only when you are aware of exactly what is attracting your attention can you begin to know how to go about painting it.

It is astonishing how a small shift in your viewpoint can totally alter the way a landscape looks. Believe it or not, these two photographs were taken at the same time, just 30 yards (27.4 metres) apart, and are actually of the same line of trees. If you look closely you can see the same gnarled tree stump in both. Which scene the artist might decide to depict is down to personal preference, but before

settling down to start it is always worth viewing the scene from different angles to see which makes the most interesting composition.

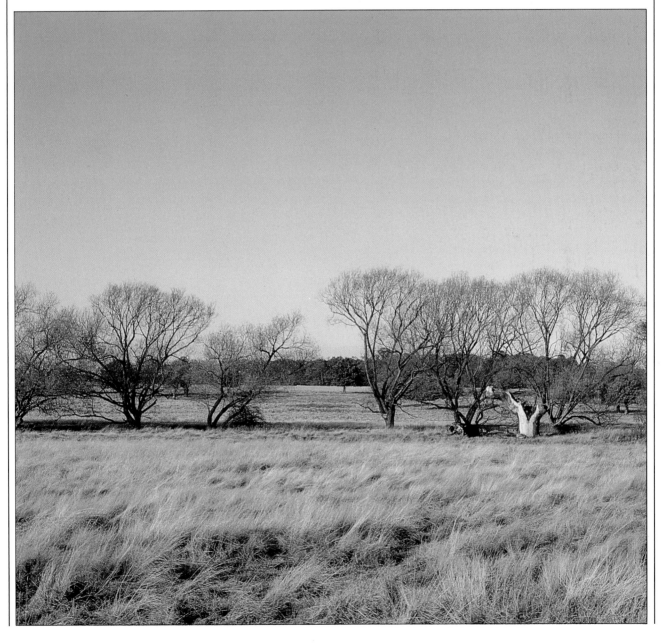

AT HOME OR OUTDOORS?

All the step-by-step projects in this book were carried out in the artists' own studios. This is not an indication that they prefer to work this way, but rather that the budget would not stretch to sending them to Greece, Switzerland, France, Italy and the USA to paint. There you have one of the major benefits of painting landscapes from home. The world is your oyster. If you fancy painting the beaches of Thailand, then just go down to the local travel agent and find a nice photograph. Obviously it would be more fun to go there in person, but can your bank balance really handle that sort of expense? – after all a travel brochure is free.

Working at home does have a number of other advantages. You are protected from the elements (intense sun can be just as gruelling as heavy rain), you do not have to put up with insects or inquisitive onlookers; you can wander off and get yourself a cup of coffee whenever you fancy, and all your materials are readily at hand. Also, rather than rushing to beat nightfall, you can take your time trying out different approaches and altering the scene to suit your fancy.

Working *en plein air* (outdoors) is a whole different matter. Whatever the advantages of working in your own home, nothing can beat sitting down in the countryside and painting or drawing a landscape. It is not some impersonal, two-dimensional photograph, but the real thing. You experience all the smells and sounds, as well as the sense of vast space and, most of all, the ever-changing light. A hill, for instance, may appear rather flat in a photograph, but when you are there at its base, it will loom up above you, and you will then be much more likely to stress this in your picture.

If you intend working outdoors it is a good idea to start close to home just to get you into the swing of it. People who trek off into the countryside for their first attempt will

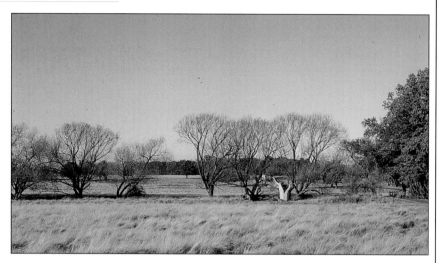

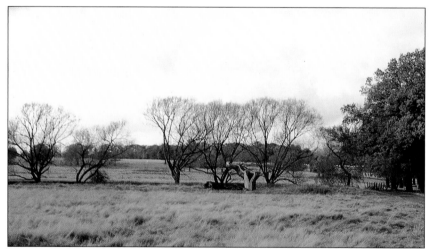

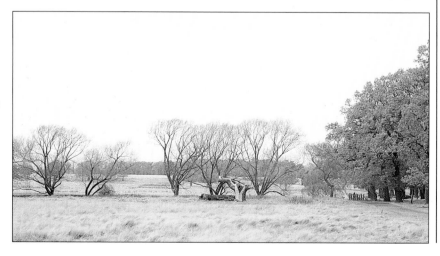

These six photographs of the same line of trees were taken over a period of two days. As you can see the whole colour scheme changes depending on the time of the day and the weather conditions. This is something that you must learn to allow for whenever you are working outdoors.

only end up confusing themselves, and in reality are most probably subconsciously delaying the moment they have to commence work. A far better start would be to paint the view from a window of your house, and then progress by moving out into the close neighbourhood – perhaps there is a park or a field nearby. The most nerve-racking thing you will find when you first venture out is how people insist on sidling up to you and commenting on your work. Try to find a spot where you will go largely unnoticed until your confidence has built up enough to be able to handle this kind of pressure.

Of course there is nothing stopping you from working both outdoors and at home. Often it is preferable to go out armed with just a sketchbook. If you find a view that takes your fancy then make a series of sketches of it. These can either be quick sketches that catch the spirit of the scene, or they can be more detailed, perhaps including written notes about colours and so on. Both will be useful to you later on when working up a painting. Photographs are also very useful, but make sure that you take a number of shots from different angles so that, once back home, you can get a feel for the true depth of the scene. Take care to use only high quality photographic film, such as Kodak's new Vericolor III or 400 professional films, both of which will produce realistic, unexaggerated colour of great subtlety, yet will also reproduce strong primary colours. In this way a sketchbook supplemented with photographs gives you the joy of going out into the countryside and then allows you to work in the comfort of your own home.

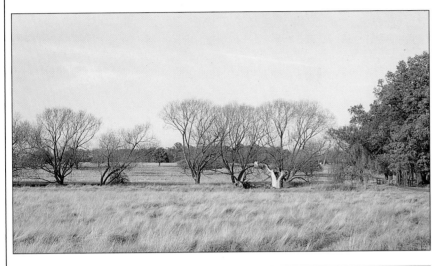

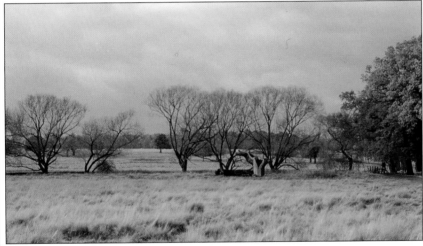

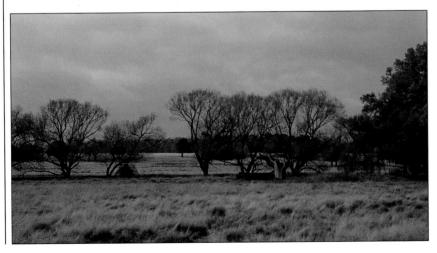

COMPOSING YOUR PICTURE

Composition is probably the single most important factor in any painting. No matter how well a picture has been painted, if the composition is bad then it will be unsuccessful. Even the most seemingly spontaneous and impressionistic painting in fact sits on an underlying 'grid' which gives the picture its structure.

The composition of a picture can be used with great effect to influence the way the scene is viewed. Some pictures have areas of interest scattered all over them. This forces the viewer to constantly scan the entire picture and can give the picture a feeling of tension and energy. A clever composition can actually manipulate the viewer, the arrangement of lines and shapes encouraging the eye to follow a course through the picture which the artist has chosen. Dramatic impact can be created by using strong contrasts of scale – large objects in the foreground, very small ones in the background – to exaggerate the feeling of depth. Particularly useful with landscapes is the use of relatively empty areas which allow the viewer's eyes to rest. These ' breathing spaces' also have the effect of enhancing the effect of stronger or busier areas.

Most modern landscape painters arrive at the composition of a picture by instinct or by trial and error, moving the various elements around until they arrive at a balanced and satisfying arrangement. There was a time when every aspect of a painting's composition was planned out with mathematical accuracy in an effort to achieve the 'ideal', perfectly balanced, composition. This was particularly prevalent during the Renaissance, and if you look at a work of this period you will almost always find a rigid arrangement of rectangles and triangles forming the basic composition. The best known of these formulae is the proportion called the golden section, which is a means of dividing up the picture space in an interesting way and working out the ideal positions for important compositional elements. Use of the golden section and its 'divine proportions' is especially associated with the Renaissance period, but it is interesting to note how so many modern paintings, when analyzed, do in fact conform to the rules of the golden section, although by no means rigidly. After all, art has more to do with intuition than with scientific theory, and most artists use this formula as a general rule of thumb rather than a dictate.

The fundamental rule of composition is that a picture should not be divided symmetrically because this creates monotony. In a landscape painting for instance, the horizon should not be placed in the centre of the picture, nor should a path or stream run exactly down the middle. Even any sub-division of the picture should not be split symmetrically in two. Similarly, a picture lacks visual impact if the main focal point is centrally placed; an off-centre placement creates rhythms and tensions which arouse the interest of the viewer.

You should experiment with your compositions without letting yourself get too embroiled in the various 'rules'. Try composing a picture using the golden section and even one with the horizon placed dead centre. You will see a vast difference between the two pictures, but ultimately you should rely on your own judgement and your emotional response to your subject, when composing pictures. After all, as the saying goes, 'one instinctively knows when something is right'.

X

Y

Z

The golden section is the division of a line into two parts so that the ratio of the shorter length to the longer is equal to the ratio of the longer to the whole line. Here the line XZ has been split in this way. The ratio of XY to YZ is the same as the ratio of YZ to XZ. This ratio is roughly 8:13 or more precisely 1:1.61803398 (a calculator is recommended!) and when you draw a line out from point Y you will have divided the area at its horizontal golden section. A rectangle can be subdivided this way horizontally at the top or bottom, or vertically left or right.

When painting or drawing landscapes one of the most important elements you must take into account is depth. Where most beginners go wrong is in failing to paint what they actually see but rather what they think they know. For example, we describe a field of grass as 'green', and so the inexperienced artist will probably paint it the same shade of green all over. This of course results in a picture which lacks realistic impression of depth and recession, because the artist has failed to observe the effects of atmospheric perspective. This term describes how the tones and colours of objects appear to change as they recede towards the horizon. Because of the intervening atmosphere, objects in the distance appear hazier, cooler and lighter than objects in the foreground. Thus a field of grass will gradually change in tone from dark in the foreground to light in the distance.

Another common mistake made by beginners is in failing to compare what they are working on with the real landscape in front of them. If you work with your support flat or at an angle your first few attempts are almost bound to end up stretched vertically with a rather flat, map-like quality to them. To overcome this problem it is best to work with your support upright, or if the medium you are using will not allow this, then every now and again hold up your picture and compare it to the real scene. You must remember that for a picture to accurately catch the perspective it should be a view through your line of sight. Regardless of whether you are sitting or standing your line of sight will be at right-angles to the ground, and therefore your picture should also show this same right-angled view.

If you alter your viewpoint even slightly when you are painting, you will upset the perspective and the picture will look awkward and unnatural. This is readily apparent if you look at the same scene sitting down and then standing up, because the level of the horizon line will change according to your eye level. When working from photographic reference you will not have this problem since you are limited to one stationary view, and you can even scale up from the photograph using grids so that you will be sure that the perspective is correct. This may sound like cheating, but even many professional artists have been known to use such methods. One very famous painter uses a slide projector to superimpose an image on a large canvas where the outlines can be marked and the image painted in.

Golden section

Although the artist probably did not consciously use the golden section formula for this painting, as you can see the horizon line falls neatly on to it. It is remarkable how many landscape painters use the golden section without ever realizing they are doing so.

PHOTOGRAPHIC REFERENCE

Photographic reference is invaluable for the modern landscape painter. However much you would like to sit down in the great outdoors and paint a scene, sometimes this is just not practical. In addition, photographs allow you to study the scene at leisure so that you can carefully consider the composition. However good a photographer you are, it is sometimes necessary to 'crop' the picture to make it more suitable for a painting or to concentrate on an area of detail within it. For instance, if in your photograph the horizon line runs dead centre, crop out some of the sky or land so that you create two areas of unequal size; this is more interesting than a symmetrical composition.

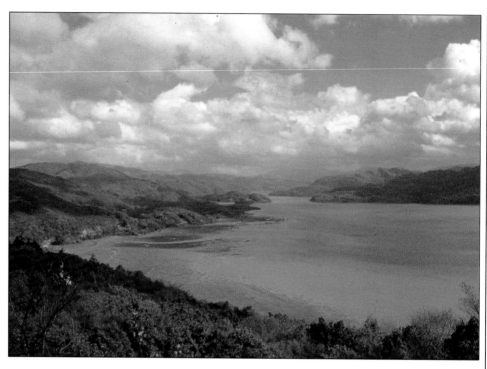

Chapter 3
Without Colour

Drawing in monochrome is perhaps the most fundamental skill that any budding artist should concentrate on. Without the insight that producing a picture in 'black and white' gives you – especially with regard to how tone can be built up – it is much harder to produce anything of great worth when working in colour. Even the world's greatest artists have sketchbooks full of drawings, and it is possible to follow this trend back in time. For instance, most people associate Leonardo da Vinci with his paintings, but it is his preparatory drawings which are really interesting. They give an insight into how he approached a painting, working out perspective and drawing figures repeatedly until they were perfect.

There are many different media which can be used for drawing, and all are challenging yet fun in their own way. In this chapter we focus on just two, charcoal and graphite pencil, but once you feel confident with these you will no doubt want to experiment with many others.

Charcoal is perfect for the beginner as it is big, bold and very responsive in use. There is no messing around as you simply pick up a stick and start to sketch.

Graphite pencils are what everyone always associates with drawing. Although they are the simplest of drawing tools, they provide a remarkable versatility, being able to depict any subject in just about any style.

Materials

CHARCOAL AND GRAPHITE PENCIL

Charcoal

Charcoal is made from carbonized vine or willow twigs and is sold in sticks of varying thickness and degrees of hardness. The softer, more powdery type of charcoal blends and smudges easily and is good for broad tonal areas; the harder sticks are best for linear details. Charcoal pencils are made from sticks of compressed charcoal encased in wood. Although much cleaner to use, you do tend to lose the 'feel' of working with traditional charcoal sticks since you can only use the point and not the side of the stick.

Other Equipment

Charcoal works well on papers with a matt, textured surface, such as Canson, Ingres or the less expensive sugar paper. As charcoal smudges easily your finished drawings should be sprayed with fixative, which binds the charcoal particles to the paper surface. If you want to sharpen the point of a charcoal stick, use a scalpel blade or a piece of sandpaper. A kneadable putty eraser is useful for creating highlights in dark areas as well as for rubbing out mistakes.

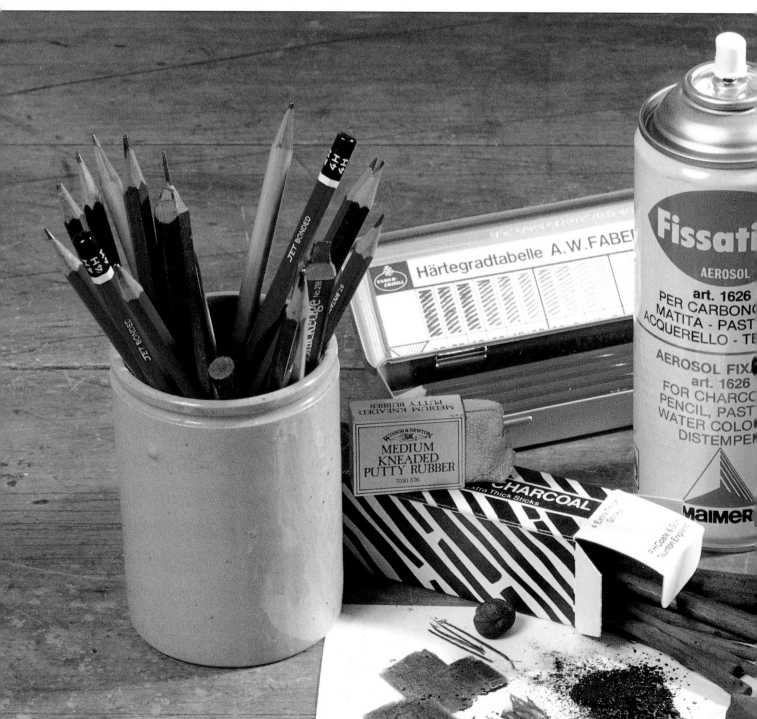

Graphite Pencil

Graphite pencils (also known as 'lead' pencils) are the most common and cheapest drawing tools around, and are basically a thin rod of graphite encased in a hollow tube of wood. They are graded from 8H (the hardest) to 8B (the softest), but the marks they make vary greatly according to the paper used. Normally the best drawings would combine many different grades, each exploiting the paper with their individual qualities.

Clutch pencils and propelling pencils are also available. These can be extended as necessary and so avoid the need for constant sharpening while you draw. Graphite sticks are used in a similar way to charcoal, and their butter-soft texture makes them great fun for large, bold drawings.

Other Equipment

It is always handy to have a good stock of papers and cards so that you can choose the one most suitable for a particular drawing. Use a sharp craft knife or a safety blade for sharpening pencils; cheap pencil sharpeners are less than ideal as they tend to break the lead. For erasing, kneadable putty erasers are cleaner in use than the familiar India rubber.

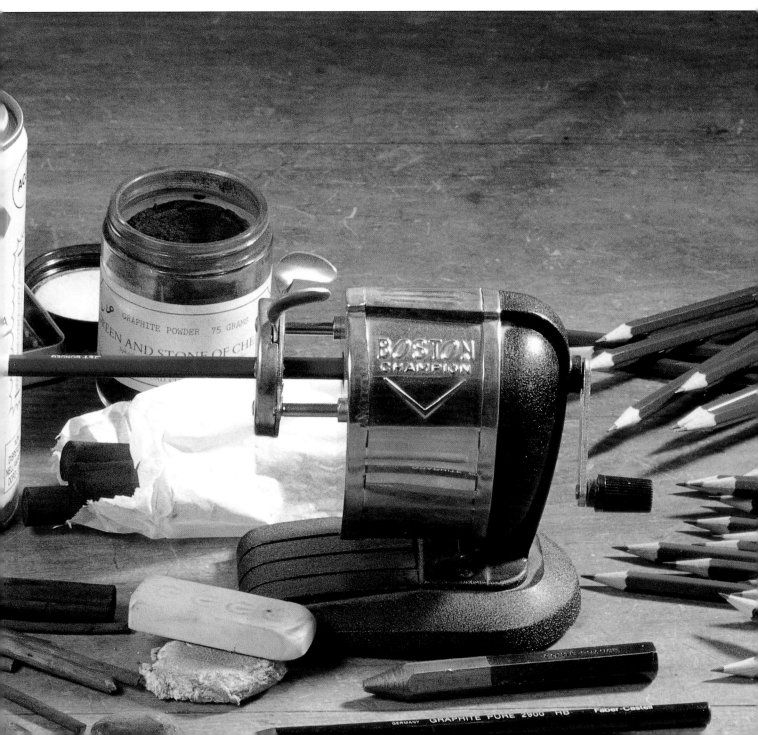

Techniques

CHARCOAL

Drawing with Charcoal

The beauty of charcoal is that it is so simple to use and it has a speed and spontaneity which encourage expressive drawing. Experiment with lines, varying the pressure to produce different thicknesses. Using the side of the stick gives a broad band which picks up the surface texture of the paper. The tip gives a solid black line with a smooth, flowing quality. For really fine lines, a sharp point can be obtained by lightly rubbing the end of the charcoal on a piece of sandpaper.

Highlights

A kneadable putty eraser can be used to pick out highlights in toned areas. Using the side of the stick, lay a solid area of charcoal. Break off a small piece of the eraser and knead it with your fingers until it is warm enough to mould into any shape. To pick out highlights, pinch the putty to a fine point and use a press-and-lift motion *without* rubbing. To smudge or subdue the tone, rub gently with a round ball of putty. The putty can also be pulled across the charcoal – as shown here – to give a band of light through dark. When the putty becomes clogged with charcoal, discard it and break off another piece.

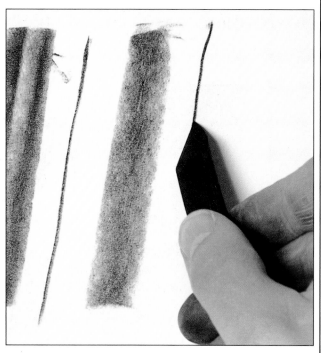

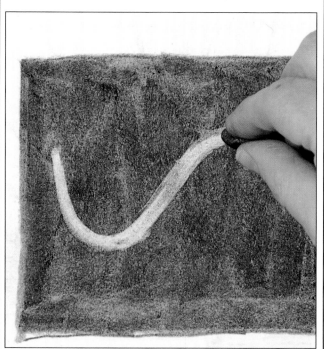

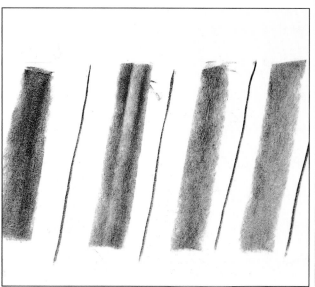

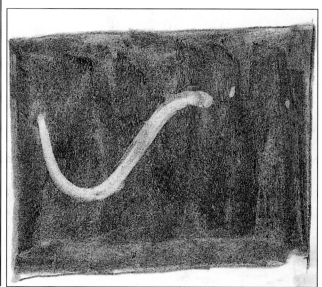

Graded Tone

The most common way of using charcoal is with a series of loose strokes (hatching) to gradually build up tone. Draw yourself a small square with the tip of the stick, and then start to slowly fill it in with loose, gentle strokes. Work out from one corner again and again with the same loose strokes, covering less of the square at each stage. You will eventually end up with an area which graduates from light in one corner to almost solid black at the other.

Soft Blending

The soft nature of charcoal means that you can smudge and blend it with your finger to create a smooth, velvety effect. Again draw a small square and then fill it in with fairly solid black using the side of a stick. Then, with the tip of your finger, gently rub the charcoal to form a graded tone which has a lovely smooth finish. You can lighten the tone with further blending, or darken it by going over the area again with more charcoal.

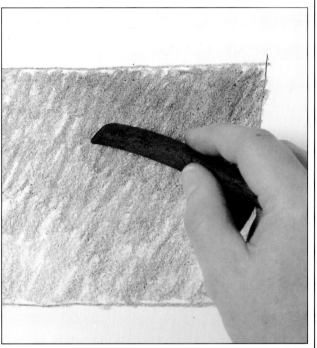

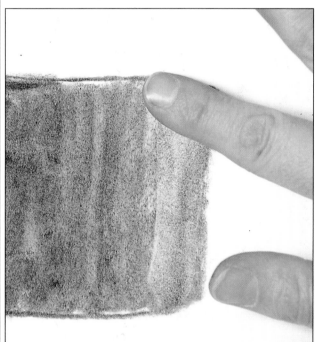

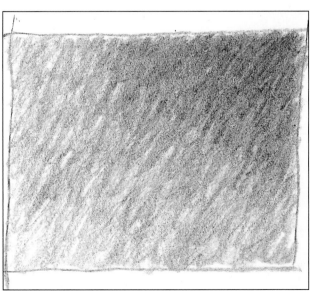

GRAPHITE PENCIL

Hatching

Solid tone and colour can be suggested in pencil using a series of parallel lines knows as hatching. This is perhaps the most basic drawing technique, and the one which most people would start to use naturally before moving on to others. By varying the weight and density of the hatched lines, a tonal variation from light to dark can be achieved easily and quickly. Straight, even lines produce a graphic effect while scribbled lines give a looser, more sketchy look. Different grades of pencil will give markedly different results, with soft pencils (in the B range) normally being more suitable for landscapes since they produce much softer looking strokes which are more in keeping with nature. With soft pencils a hatched area can be lightly blended with the fingertip to produce textural variety. Hatched lines need not be straight; they can curve to follow the contours of an object, emphasizing its form.

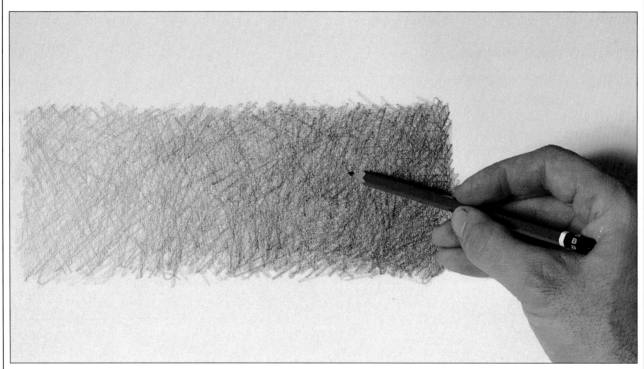

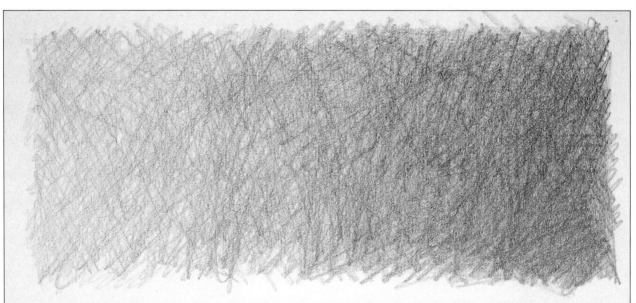

Crosshatching

This is a development of hatching, in which two or more sets of parallel lines are combined, one set crossing the other at an angle. Although originally developed for engraving, this technique can be used with all types of linear media, and some very interesting results can be achieved if you are prepared to experiment. As with hatching, graduations of tone can be achieved by varying the density of the lines: the more closely spaced, the darker the tone. The lines can be crosshatched at any angle you like, and even curved. Generally, freely drawn lines look more lively than perfectly straight ones.

In theory an entire drawing can be produced using crosshatching, but it is a labour-intensive technique. More often it is used in small areas of a drawing, its crisp, linear effect providing a textural contrast with the softer lines and shading used elsewhere.

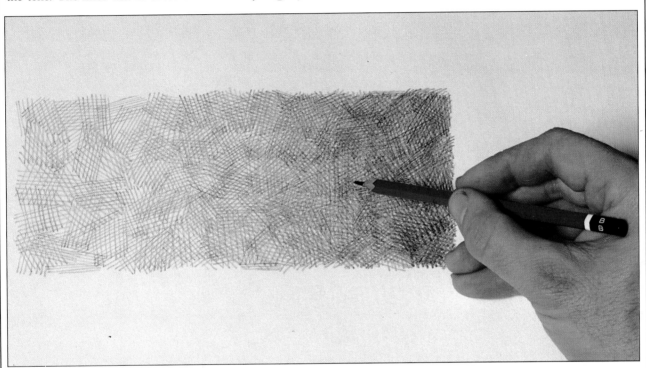

Country Lane

CHARCOAL

Most people seem to have a romantic, idealized view of the solitary landscape painter, sitting in the open countryside with his trusty easel and palette, at one with Mother Nature. In reality, working out of doors is not always a practical option. Even in the sunniest of climes, the weather can change from day to day and as the sun moves across the sky the shadows and colours will alter from hour to hour. Do not get us wrong, for there is nothing more pleasurable than sitting in the open and feeling a part of what you are actually painting, but your time will be limited to certain parts of the day and, depending on the complexity of your painting, might mean that the project could take weeks. In days gone by artists had no choice but to work in the open, or from sketches made in the open, but with the invention of the camera the artist's life has changed dramatically.

In fact the camera allows the artist a great deal of freedom and spontaneity. The artist chanced upon this scene while out walking in the country and felt it would translate into a painting. Unfortunately he was not carrying his paints, but he did have his camera with him, so he was able to take several shots of the scene and add them to his own personal library of landscapes. Thus, when it came to choosing a subject for this charcoal project he had a wealth of images to choose from. This particular one seemed to lend itself well to the medium of charcoal, partly because it contained very little colour and so could easily be translated into a monochrome rendering without losing any of its beauty, and also because it contained certain details that could be executed in the loose style of charcoal without losing any impact.

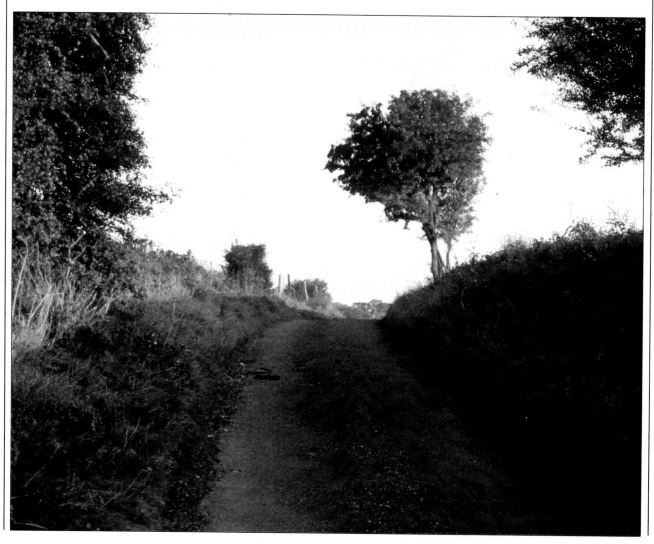

1 As this is partly an exercise to prove that you can create an entire image with just one stick of charcoal, your best bet is to go for a nice, extra thick, weighty one. This will give you the best of both worlds, enabling you to cover solid areas quickly using the side of the stick and to draw fine lines and details with the sharpened point. Map out the rectangle in which you will be working and then refer back to the original image and start to loosely sketch in the main elements of the composition. In keeping with this fluid medium, try to relax and work loosely. Hold the charcoal stick lightly between your thumb and forefinger and let the point glide over the paper. It is also a good idea to make practise strokes on a piece of paper before starting your drawing.

2 As you work, you will soon get used to the feel of charcoal and enjoy the way it glides softly over the paper. Do not worry about detail and tight outlines, just start by loosely mapping in the areas that will contain the darkest shading – the bushes and the foliage of the tree. Do this by using the side of the sharpened end of the stick.

3 The bushes at the back on the left-hand side are much smaller, so this time you are going to use the sharpened point of the stick to create finer marks. Following the contours of your original reference, block in the bushes, applying slightly more pressure with your stick of charcoal, and at the same time adding some more detail. One of the advantages of charcoal is that if you make a mistake you can easily erase it with the tip of your finger, leaving an almost clean surface underneath.

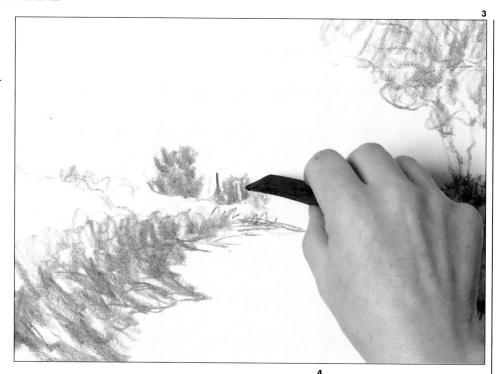

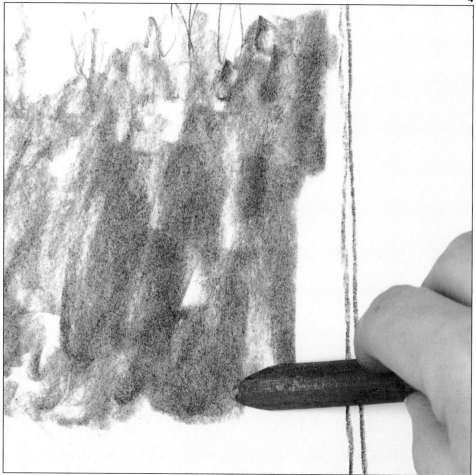

4 Moving down to the right-hand side of the drawing, loosely fill in the rest of the bushes. To do this use the whole side of your stick, which allows you to cover large areas quickly. Remember to keep the pressure fairly light as charcoal is a soft medium and if you press too hard you will end up with a lot of loose 'dust' on the surface of the paper. Not only that, the fragile stick will probably snap!

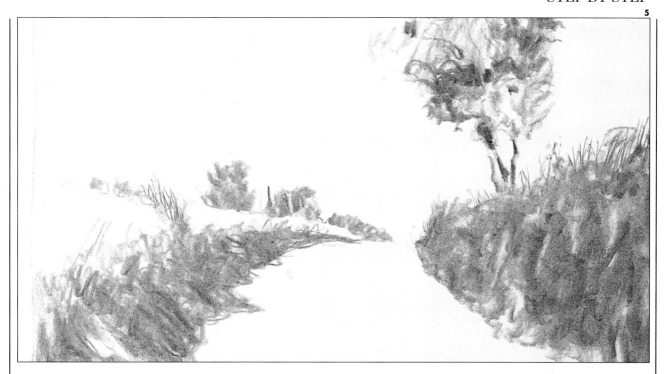

5 Now that you have mapped in all the major dark tones of your drawing, switch to the sharpened end of your stick once more and 'tickle them up' by adding a few extra details such as the individual branches growing through the tops of the bushes. To prevent smudging, keep your hand above the paper at all times, and from time to time gently blow off the excess charcoal dust from the surface.

6 By now you will probably have realized that charcoal is a pretty messy medium! Therefore at this stage it is a sensible idea to spray fixative over the whole drawing to prevent smudging of your work and allow you to add some more detail. Tape your drawing to the drawing board and set it upright against a wall. Holding the canister of fixative 18 in (45cm) away from the drawing, spray *lightly* from side to side. Do not overspray – if the fixative runs it will ruin your drawing. When the fixative has dried, use the sharpened end of your stick to introduce the branches of the tree on the left.

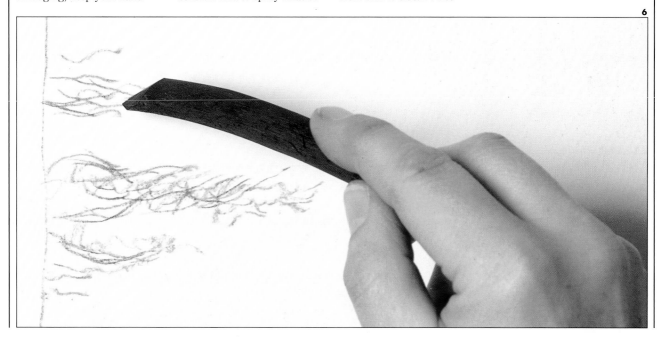

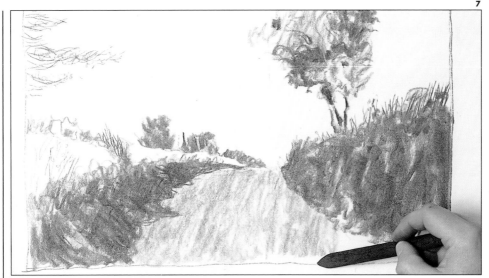

7 With the side of the sharpened end of the stick block in the first layer of the lane and add a little more detail to the tree on the left-hand side. This is again a good point to spray the whole drawing with fixative.

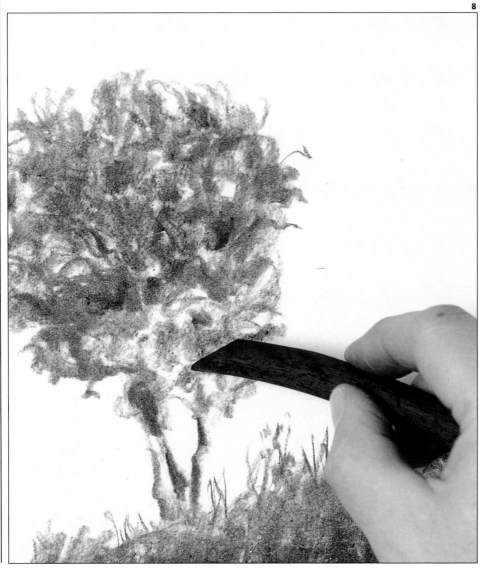

8 From this stage on you are going to be bringing into focus all the individual elements of your drawing. Using the sharpened end of the stick, start by adding more tone to the tree on the right. We use the word tone as charcoal is not suited to minutely detailed work, which is why it is also a very fast way of working. Use short, irregular strokes to indicate the texture of the foliage. When you are satisfied with the result lightly spray the area with fixative.

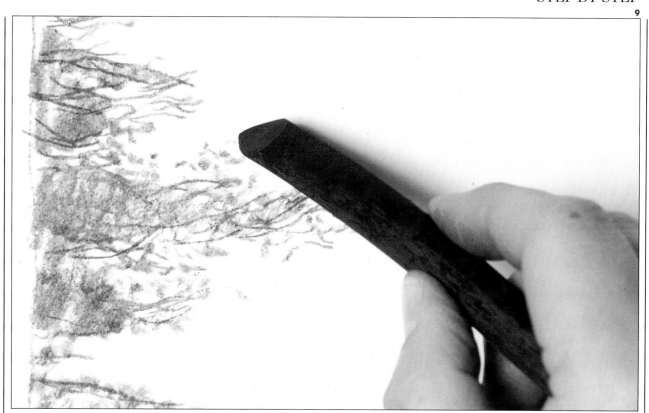

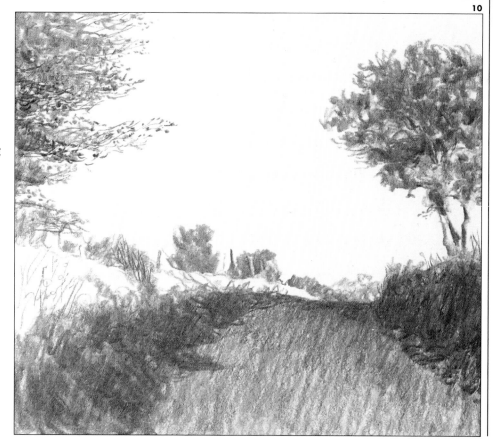

9 Having completed the main focal point on the right-hand side you can now move over to the left. Originally the tree on the left was rendered quite simply, with only a few odd branches indicated, but to give a sense of balance to the overall image, these branches will need to be extended. Using the sharpened end of the stick, work up the branches and indicate the leaves with scribbled marks. Spray once again with fixative.

10 Now take an appraising look at your drawing so far and decide which areas you need to work up next. By this point the bushes and the lane will have shrunk into the background so they will be your next line of attack. Resharpen the tip of the charcoal stick on a piece of sandpaper then work over the bushes and add another layer of tone to the lane.

CHARCOAL / COUNTRY LANE

11 You can now start adding all those little finishing touches. In fact adding is the wrong word, because what you will be doing is knocking back. Using a putty rubber you can lighten tones such as those on the tree by applying gentle pressure and executing a sort of dabbing technique. This will remove the fixative as well, but be careful to avoid pulling the surface off the paper.

12 Returning to the left-hand side, the bushes need just a little more detail. Using the sharpened end of the stick, add a few extra squiggles, but do not overwork the details as this defeats the object of working in such a broad and expressive medium and can actually spoil the drawing by making it look rather lifeless.

13 At this point your drawing looks very finished, but stand back and use your own judgement as to whether or not it could be improved upon. In fact at this stage it is often a good idea to leave the drawing for a while. When you come back to it with a fresh eye you will spot any mistakes instantly. In this particular case the artist felt that the tones of the bushes and the lane could be darkened up a little to achieve a better balance of tones.

11

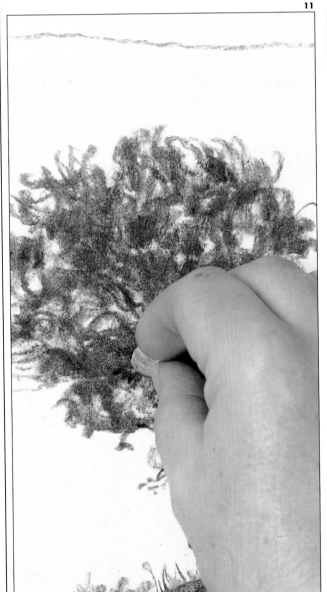

12

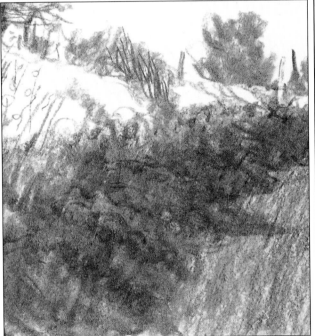

13

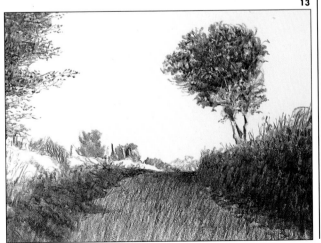

14 On further reflection the artist felt that the lane itself looked decidedly dull and flat. To correct this he decided to use the knocking back technique, gently pressing over the area from left to right with a putty rubber to give a slightly graded tone and create the illusion of a shadow.

15 Now it really is time to stop. Any more work would be totally unnecessary and after all, part of the fun of charcoal is the speed at which you can go. Even in this example, where the artist did in fact pay some attention to detail, the actual rendering of the drawing was still very fast. All that remains now is to spray the whole drawing with fixative so that it can be stored away without it getting smudged and ruined. So whatever you do, avoid a tragedy and always spray your drawing, even before you stand back to admire your work.

14

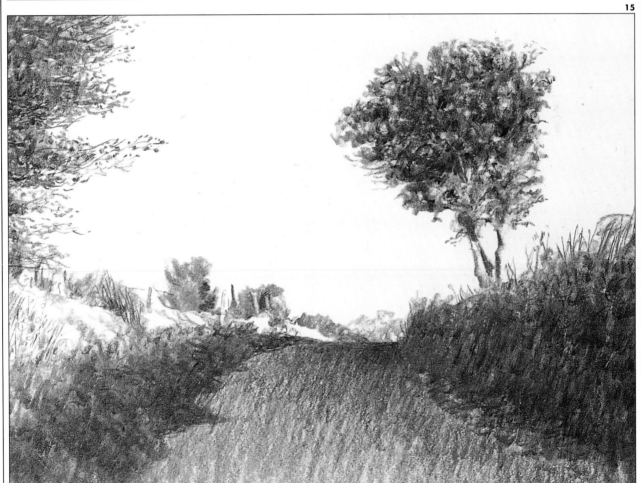

15

New York's Central Park

GRAPHITE PENCIL

The reference for this project is a photograph the artist took while on a trip to New York. He went for a stroll in the famous Central Park and was struck by how beautiful it looked, especially with the blanket of snow covering the ground. Being the ever-ready artist he is, he had his camera at hand and was able to take a number of shots. The only thing that could have made the experience even better was for it to have actually been snowing as he was standing there – it was close to Christmas after all!

The artist selected this image because he knew that its stark, monochromatic beauty would translate perfectly to a drawing in graphite pencil. However, as you will see, he did not slavishly copy the scene but used it as the basis for a composition of his own. He decided to omit the fence, the path and all the other man-made elements of the picture, and to include large flakes of falling snow to create an image with a delicate, dreamy quality.

This is one advantage of working from a photograph. If the artist had sat down in the park and sketched the view, not only would he have been exceptionally cold (and probably mugged!), but it is likely he would have depicted the scene as it was. The photograph allowed him to 'step back' from the view and make calculated decisions about what he actually wanted to draw. There is absolutely nothing wrong in altering the elements of a landscape if necessary in the interests of what you want your picture to say. If something looks very complicated or spoils the rest of the scene, then by all means leave it out. There are no rules, you can depict whatever you want. In fact some artists simply make up landscapes that they feel they would like to see. There is nothing wrong in this, art is meant to be for enjoyment, not to conform to someone else's standards.

For this picture a large range of graphite pencils and sticks is used to capture all the subtleties of tone as the trees gradually blend into the background haze as they get further away. A common mistake when starting out with graphite is to stick to just one or two pencils. As pencils are cheap there is no reason why you should not buy a complete range, which will give you far more scope for creating interesting textures and effects as well as enabling you to produce a more subtle range of tones.

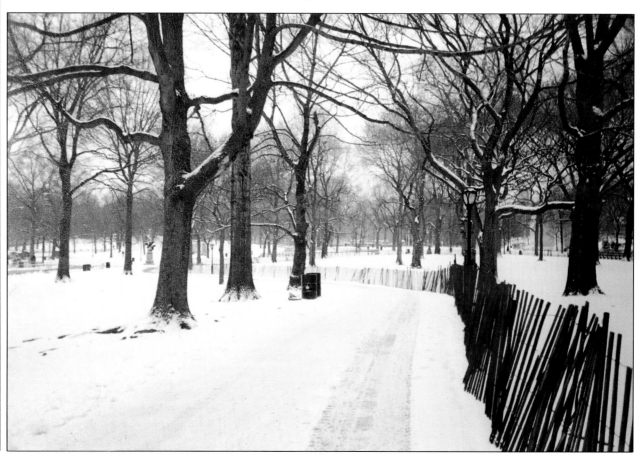

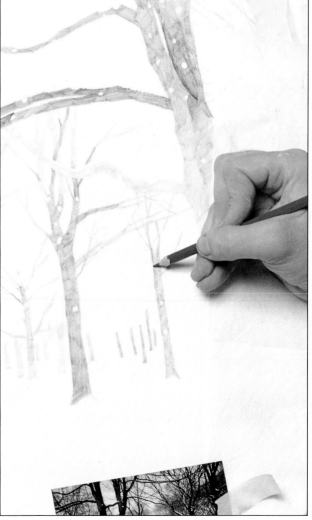

1 On a large sheet of smooth, heavy cartridge paper lightly sketch in the outlines of the trees with an HB pencil. These lines are for your reference only, so keep them very faint. Then, using an F pencil, start on the large tree to the left, building up the form slowly with light crosshatching. An F pencil is good for starting a drawing with because it does not deposit a large amount of lead onto the paper.

2 Once you have marked in where these first few trees are with your light crosshatching, go back over them with a graphite stick to darken down the tones, and then add in some of the smaller branches

in the background. Note how the artist is resting his hand on a piece of kitchen tissue to prevent smudging the work he has already done.

3 Now switch back to a graphite pencil, but this time a B, to continue the darkening of tones in this first area of the picture. Leave occasional white spaces in your work to indicate flakes of snow gently falling to the ground. You could alternatively indicate the snowflakes when the drawing is complete, by using the corner of an eraser to rub out small areas; but by leaving the paper showing through from the start you will get much crisper spots of white.

4 Continue working over this quarter of the picture, switching from graphite pencil to stick as you complete each progressive layer of crosshatching, putting in more detail at each stage. You may think that this approach of building up the darker tones by going over them again and again is unnecessary, and that it would be far simpler to launch straight into them with a 6B pencil for example, but you would be wrong. Not only does this considered approach allow you to adjust the tones slowly until they are perfect, it also results in a much richer variety of tones and textures, from areas that are crosshatched only once, up to the darkest areas that are worked on numerous times.

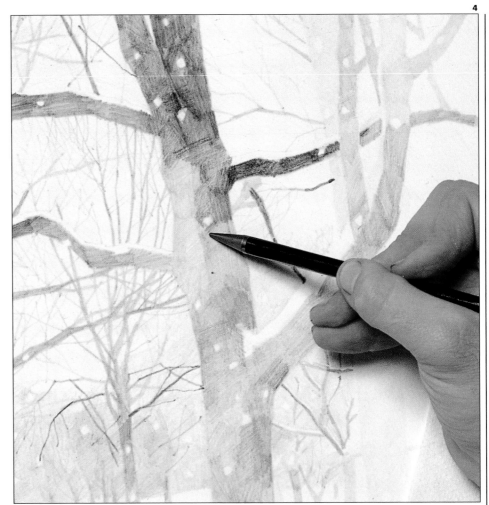

5 By concentrating on one section of the picture at a time you will find it much easier to put in the amount of detail that is required to make this type of drawing work. If you try to work over too large an area at the beginning you may find yourself getting 'lost', and the finished picture will suffer as a result. Now that the first quarter of the drawing has most of the detailed areas mapped out, it is time to move on to the next section. Rather than diving straight in, first work along a couple of the long branches that create a natural bridge from one side of the picture to the other.

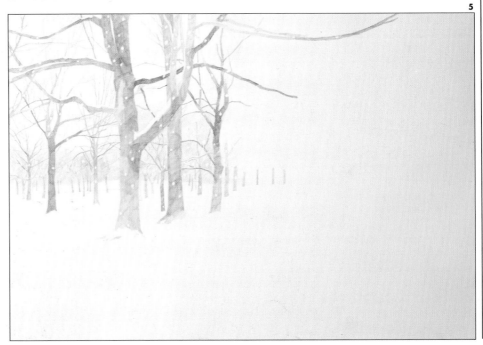

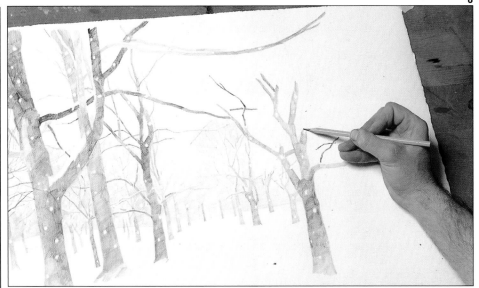

6 Now you have to start the lengthy process of building up tone all over again for this second section, but at least you now have the first part of your drawing for reference, so you should be able to aim for the correct tones in fewer steps. If you have enough time and patience to build up the tones slowly and methodically, you will find this technique highly absorbing, and the results will justify all your hard work.

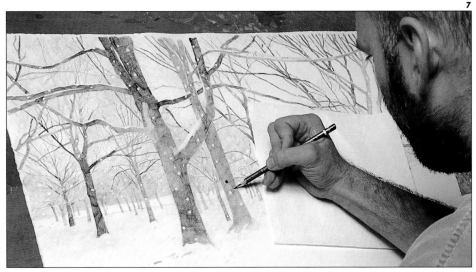

7 Once all the trees and their branches are in place you can go back to add in all the finishing touches to the top half of the picture. In order to give the scene a convincing sense of depth, the tones should graduate from dark and strong in the foreground, to pale and hazy in the distance. The tree trunks in the foreground should therefore be the darkest part of the drawing, so quickly crosshatch these again with a B pencil, and then for the very darkest areas use a 6B.

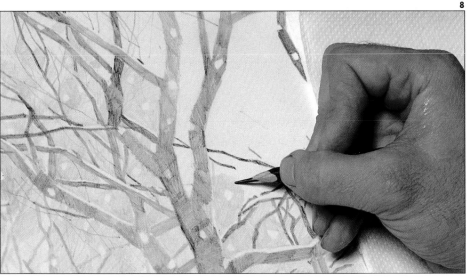

8 To recreate the hazy blur of thousands of branches and twigs stretching off into the distance, use an HB pencil and lightly crosshatch right across the area, filling in all the gaps between the trees. Make this crosshatching solid along the horizon, and gently fade it out towards the top of the foreground trees. Remember to leave spaces for snow flakes as you are doing this – the drawing will look very odd with snow falling only in front of the tree trunks and solid branches!

9

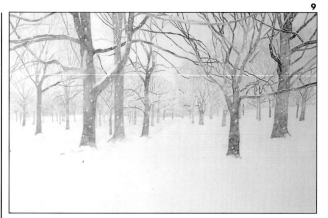

10

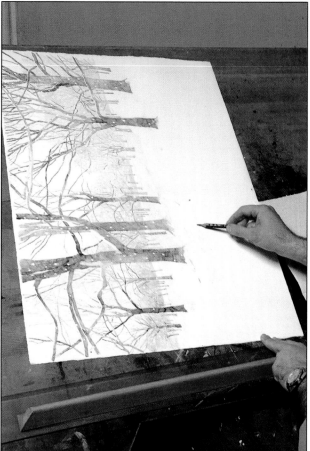

9 You can now step back and take a critical look at your work, because you are almost finished. The lower half of the paper remains uncovered at this stage, but as this is going to be fallen snow which is white anyway, only a hint of shading will be required.

10 Using an HB pencil, lay down a light tone over the remaining white paper with some very loose crosshatching. Place the paper at a slight angle so that your strokes can be long and relaxed.

11 To finish the drawing off, rub out some loose patches all over the foreground crosshatching which you have just laid, to soften the overall texture. If you look at even the most freshly fallen snow you will see that it does not sit as a pure white cover. Rather, where there are undulations in the ground, it catches the sun or falls into shadow, creating a range of subtle tones.

11

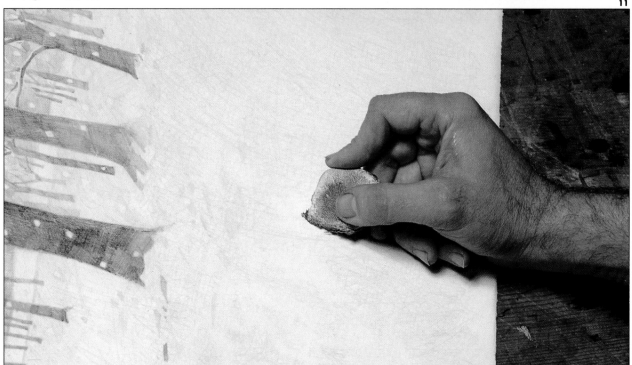

12 This is one of numerous ways of drawing a landscape, and perhaps one of the slowest and most complicated. Many artists favour a particular approach to drawing and then try to make every landscape they do fit their preferred style. Although there is nothing wrong in this, it is not advisable for beginners to limit themselves to a certain style or technique too early on. In this case the artist selected a drawing style which he felt was appropriate to the subject – tight crosshatching built up slowly to mimic the tightly interwoven branches of the trees and to catch the individual flakes of falling snow. However, the same scene under storm or blizzard conditions would have required a very different technique, using loose sketching to capture the wildness and ferocity of such intense weather conditions. It is important to experiment as much as possible with different styles, then once you have tried them all you can go back and perfect the ones you like the most. But even then, think about the nature of a scene before you select the style to draw it in; that way your pictures are much more likely to succeed.

12

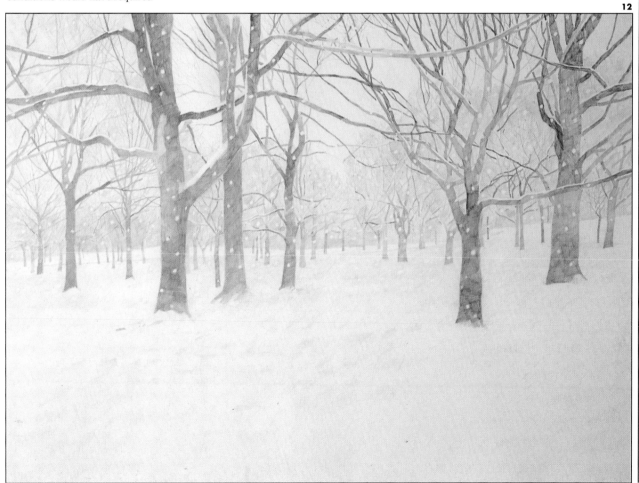

Chapter 4
Dry Colour

Dry colour refers to any medium which can be used to produce a drawing or sketch in colour. The two most popular examples are coloured pencils and pastels, which we will concentrate on in this chapter, but there are many other media which you can also use in this way. A few worth experimenting with include conté, wax crayons and studio sticks.

The subtle effect that coloured pencils produce has become extremely fashionable over the last few years, particularly for magazine and book illustration. Examples are to be seen all around you, from the packaging of food products in your local supermarket to advertisements for hi-tech computers on huge billboards.

Pastels are very difficult to match for their ability to produce quick, on-the-spot sketches where a bold approach is required. They come in a vast range of sumptuous colours and are so versatile that they can be used both as a painting and a drawing medium. More recently oil pastels and pastel pencils have been developed to further increase the scope of this medium. Pastels really came into popularity about two hundred years ago with their extensive use by the French Impressionists, particularly Edgar Degas, and have remained a firm favourite with artists ever since. This is hardly surprising given their amazing versatility and the fact that it is so quick and easy to learn how to use them successfully.

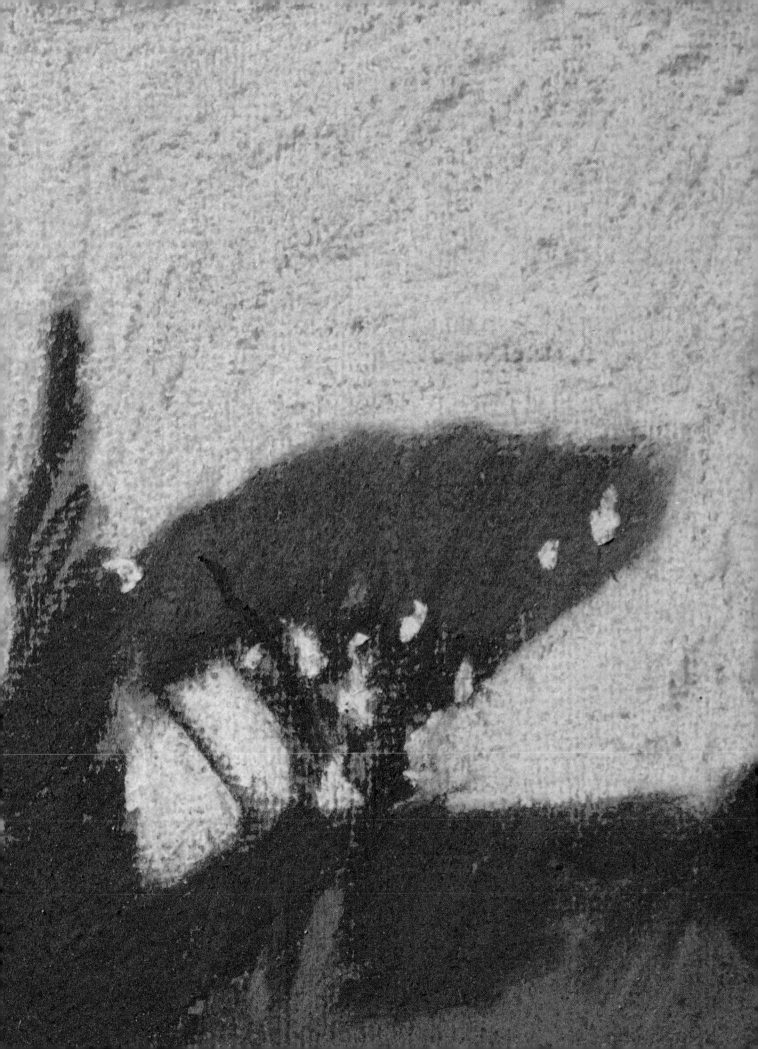

Materials

COLOURED PENCIL AND PASTEL

Coloured Pencils

Coloured pencils are made from a mixture of pigments and clay which is bound with gum, soaked in wax and pressed into rods encased in wood. There are hundreds of different colours to choose from, but bear in mind that the range of colours varies from one brand to another. They also vary in quality: some can be very hard, others soft and crumbly. It is therefore advisable to stick to a single brand, if you do not want to keep changing your technique to suit different pencils. Watercolour pencils are also available, which allow colours to be dissolved with water and blended on the paper.

Coloured pencil marks are much harder to erase than those of ordinary graphite pencils. You can scrape them off with a scalpel blade, but then you run the risk of destroying the surface of the paper.

Pastels

Pastels consist of powdered pigments mixed with just enough gum to bind them together. The resultant paste is then moulded into sticks and sold individually or as boxed sets. They are sold in three grades: soft, medium and hard. Soft pastels produce gentle, velvety marks and brilliant colours but can be messy to work with. It is best to experiment with all three grades to find out which is the most suitable for you.

Unlike liquid media, pastels cannot be mixed on a palette to form other colours. Every colour, and every tint or shade of that colour, requires a separate pastel stick. This explains why there are literally hundreds of different tints to choose from. However,

there is no need to purchase such a vast range (unless you are feeling very extravagant), since to a certain extent colours can be blended once on the paper. A basic range might consist of only a dozen sticks, but a more realistic figure, to provide plenty of scope, would be in the region of 40 to 50, with added sticks as required.

Oil pastels are also available. Because they have an oil binder they do not crumble or smudge excessively. Instead of a soft velvety texture, oil pastels make thick, buttery strokes. Their colours are clear and brilliant, but harder to blend, though you can work into them with a brush dipped in turpentine.

Supports

To a large extent the effectiveness of a work in coloured pencils or pastels depends on the colour and texture of the support used. The surface of the paper must be rough enough to rasp off the colour as it is drawn across and to retain the resulting powder. The colour of paper is important because often parts are left showing through to create highlights or to add to the general mood of the picture.

Good quality drawing or watercolour paper is usually perfectly adequate, but many papers are specifically made, in particular for pastels. Of these Ingres paper is perhaps the most reliable and cost effective coloured paper to use. But also worth considering are those with fine sandpaper surfaces or with velvety surfaces.

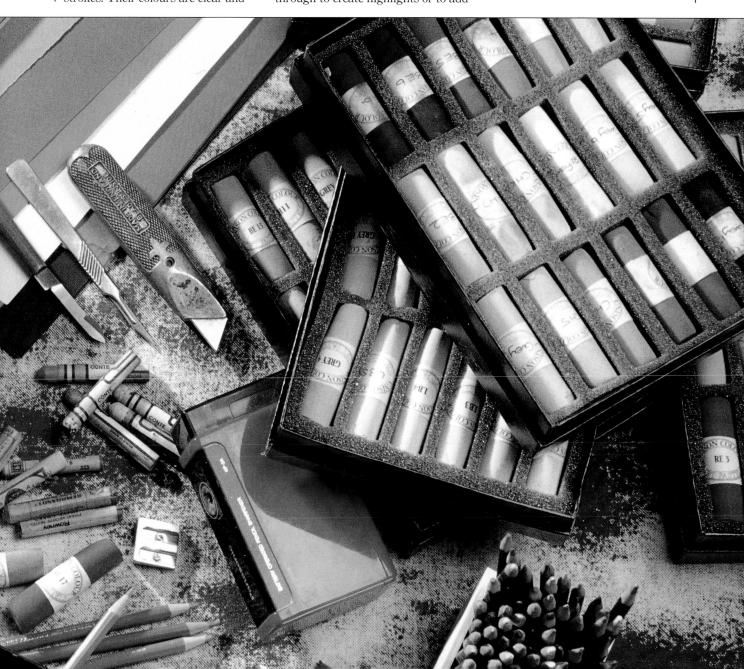

Techniques

COLOURED PENCIL

The beauty of coloured pencils lies in the infinite range of luminous colours you can achieve through optical mixing. Colours cannot be physically mixed together on the palette as they can with paints, but they can be layered, juxtaposed and semi-blended. From the appropriate viewing distance these colours appear to blend together, but the effect is more vibrant than an area of flat colour because the strokes are broken up.

Loose Mixing

The easiest form of optical mixing with coloured pencils is loose mixing. With this you get a very impressionistic effect with only the merest suggestion of blending. Mark out a small rectangle and then loosely sketch in some strokes of green, starting at one end and fading out about two thirds of the way along. Work in from the other end with a red pencil in the same way, and then finally use blue to sketch over the middle. As you can see, the three original colours are still very obvious, but there are interesting hints of purples and oranges as well, creating a gradual change of colour from green to red.

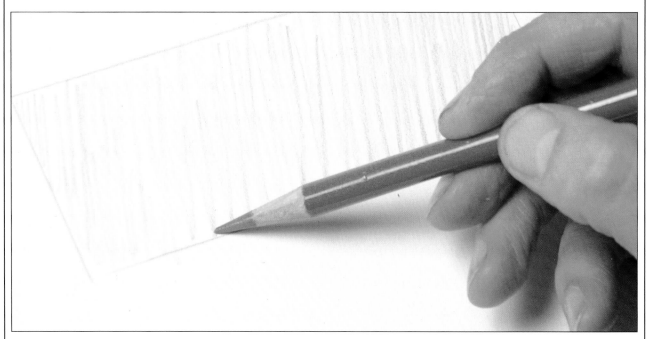

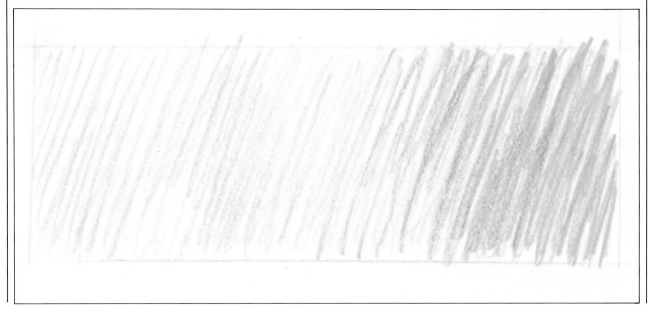

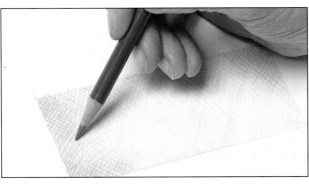

Crosshatching

Crosshatching is basically the same as the previous exercise, but much more time and precision is put into it to create a far more subtle blend of colours. Carefully crosshatch over the entire area with an orange pencil, and then go over the ends with red and then brown cross-hatching. Apart from creating an interesting textural effect, the overlaid strokes produce colour mixes where they intersect with each other.

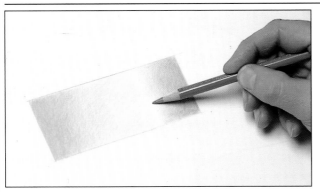

Soft Blending

This involves laying flat colours over each other to form resulting blends, or the gentle flow of one colour into another. This is harder than it sounds since, if you proceed too quickly or apply too much pressure, the tones will get too dark to work with. Using orange and blue pencils, and very gentle circular movements, slowly work in the two colours from either end until there is just the suggestion that they meet. Hold the pencil almost flat, between your thumb and forefinger, so you are using the side of the pencil head and not the tip.

PASTEL

Linear Strokes

When taking up pastels for the first time it is important to practise the various strokes that are achieved by using the stick in different ways. Although the pastel used in these examples is a special hand-made type which is much fatter than the normal, commercially produced varieties, the basic strokes are identical. Using the pastel on its side *(1)* produces a broad band of colour which is perfect for filling in large areas. By running the edge of the stick down the paper *(2)* you get a thin line of dense colour. A flat end of the pastel *(3)* produces a band of colour as thick as the pastel. Finally, by sharpening the pastel to a point *(4)* you will get a very thin, sharply defined line.

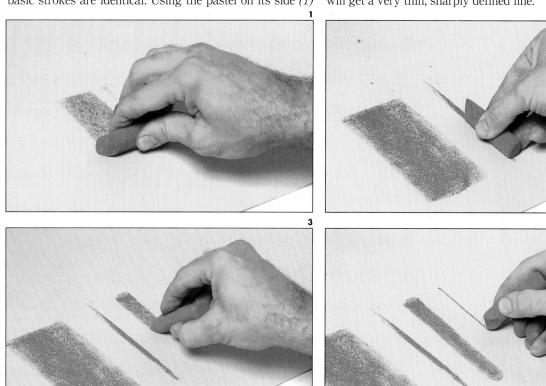

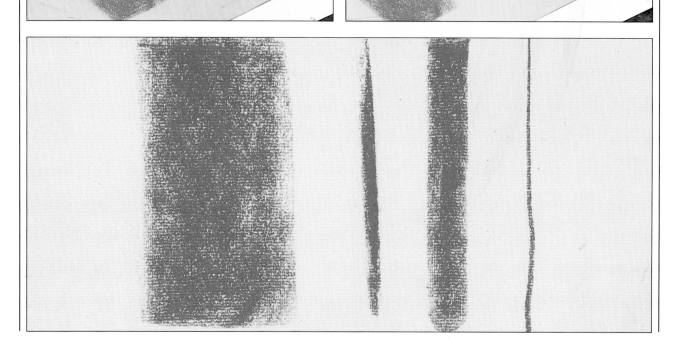

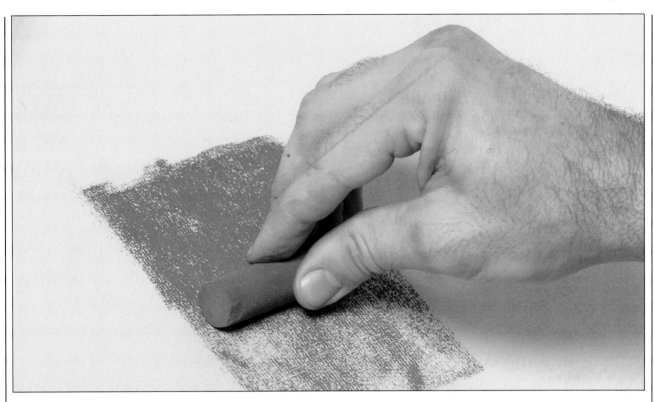

Building up Colour

When you cover an area with the side of a pastel stick the pastel catches on the raised tooth of the paper, particularly if the paper has a rough texture. This produces a very pleasing, broken effect that can be successfully used in many pictures. If a more solid tone is required then it is simply a matter of building up the colour by repeatedly going over the area with the side of the stick, but note how you still end up with some texture in your block of colour.

PASTEL

Blending

When one pastel colour is drawn over another they will naturally blend on the paper to form a mixed colour. Loosely scribble in an area and then go over it again with another colour. As you go over in the second colour you will find that it picks up and mixes with the colour underneath. If so desired, these can be further blended by gently rubbing over the area with your finger, a torchon, a brush or a piece of tissue. Take care not to get too carried away when blending colours; when overdone it can make a picture look very murky.

Feathering

Feathering, as the name suggests, involves placing light, feathery strokes of one colour over another so that the one below still shows through but is modified by the feathered strokes. Feathering is a useful way of enlivening an area of colour which has gone 'dead'. Use one colour to scribble in an area, and then spray it with fixative. Once this has dried, feather in another colour over the top. As you can see, the colours remain separate and distinct to create a very pleasing effect. This can look particularly lively if complementary colours, such as red and green or blue and orange, are feathered over one another. Feathering works best with a hard pastel – soft pastel is apt to smudge.

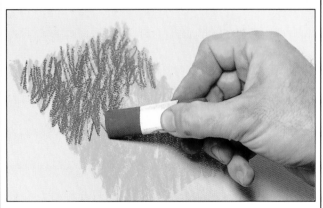

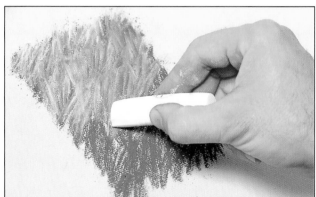

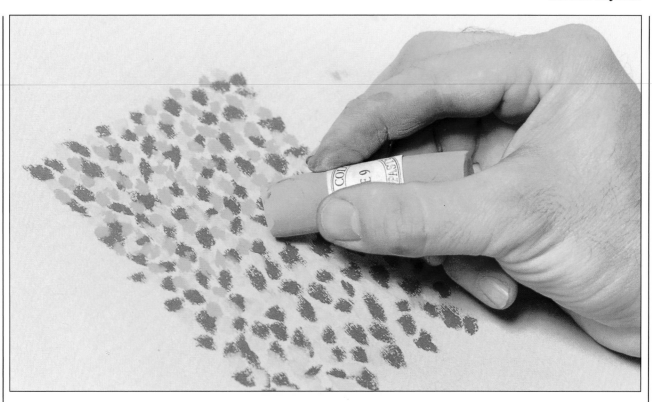

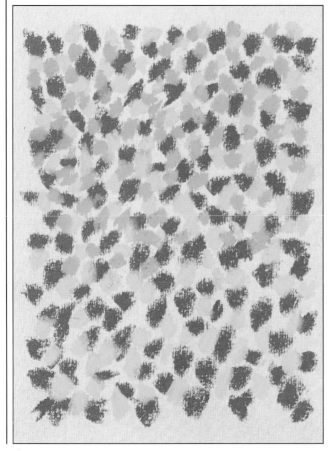

Pointillism

The word pointillism is derived from the French word *point*, meaning dot. The technique of pointillism involves building up an area with small dots of pure colour which are closely spaced, but not joined, allowing some of the toned paper to show through. From a distance these dots appear to merge into one mass of colour – for instance, dots of blue and yellow will appear as an area of green – but the effect is more vibrant than a solid area of colour. However, it is important to note that this vibrancy is only achieved when the colours are of the same tone. Pastels are perfect for this effect because of their pure, vibrant hues and due to the fact that the dots can be laid very quickly with the sharpened end of a stick.

Four Trees

COLOURED PENCIL

The delicacy and simplicity of this image makes it an ideal choice for rendering in coloured pencil. Although often associated with children and colouring books, coloured pencils really do have a lot more going for them and are capable of producing a very subtle, delicately textured effect. Although the dense, waxy nature of this medium means you cannot easily blend colours together as you can with, say, pastels, this is not a drawback. Indeed, the beauty of coloured pencils lies in the range of shimmering hues you can achieve by building up separate strokes of colour, which resonate against the white of the paper.

Although this drawing project is a very simple one, it offers those of you who are new to this medium a chance to try out a variety of techniques, which range from rendering fine details to covering broad, open areas.

Incidentally, this particular project also demonstrates the value of keeping an open mind and using your imagination. Here, for example, the artist turned a potential disaster into a 'happy accident': what happened was that he had a laser copy made from his original reference transparency, but the copy came out too dark. Undaunted, he capitalized on the fact that the sky now had a very purple hue, and as you can see, it has given the picture an added sense of drama.

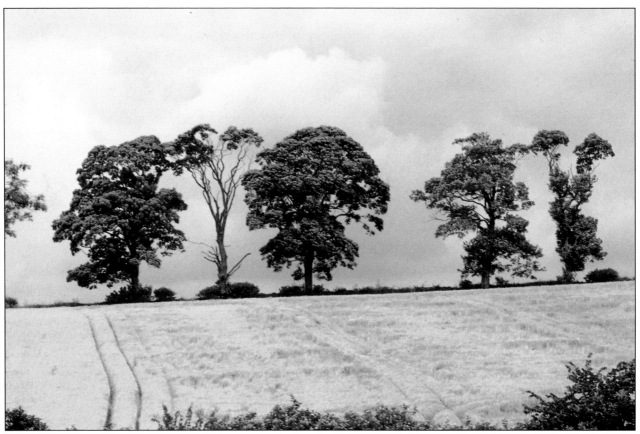

1 The focal point of this landscape is the trees, but on looking at the original reference the artist felt that there was too much space between them, making the image too static and bare, so he decided to pull the trees closer together. Using a pale orange pencil, start by mapping in where the trees will stand. With coloured pencils it is always advisable to use very pale shades for your initial sketch so they will not intrude on the finished piece. Switching to pale blue, draw the outlines of the clouds. Referring to the colours in the laser print, take a purple pencil and loosely hatch over the cloud areas. This will add drama later on.

2 Using the orange pencil, loosely sketch in the field in the foreground. To create an overall sense of colour harmony in your drawing, use the purple pencil to sketch over the fields, employing the same loose style and applying very little pressure.

3 Now you can start pulling things into shape. Choosing a deep shade of green, begin adding form to the bushes on the horizon, still sticking with your loose, sketchy technique.

4 With the same green pencil, move up towards the trees. Do not cover the trees totally with green but concentrate on the areas of dense foliage to add definition. Do not be tempted to press too hard with your pencils, otherwise the surface will become shiny and unworkable and prevent you from building up further colour as the drawing progresses. Instead, build up the colour gradually with delicate strokes, leaving plenty of the white paper showing through.

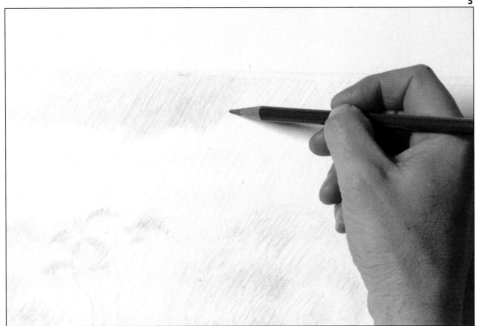

5 Choosing a deep shade of blue, darken the tone of the sky in between the clouds. At every stage now your drawing will take on a new dimension. You can see how, rather than starting with a tightly defined outline and then just filling it in, this way of working also gives you a little more freedom and allows you to make changes as you go.

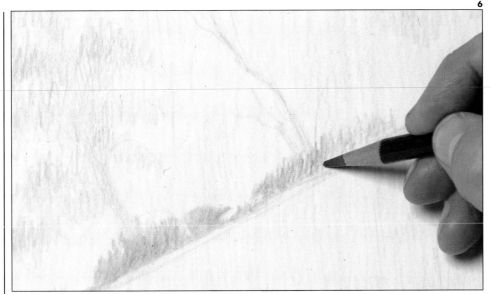

6 Now go back to the bushes on the horizon. Holding your green pencil much closer to the point, and applying more pressure, add further strokes of colour to give an impression of their form

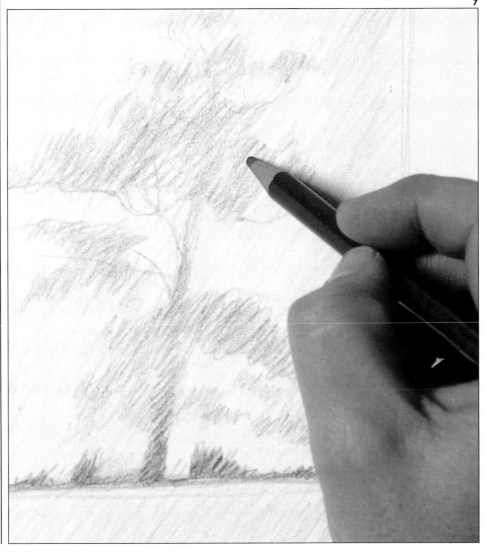

7 As explained earlier, purple is going to be used as the unifying colour, so, as it has now become almost invisible, it is time to re-introduce it. Reverting back to your loose technique, gently re-work the trees, sky and field, and also add the outline of the track.

8 Now it is time to do some real work on the trees. These are the most important part of your drawing and require special attention in order to make the finished image work successfully. A good starting point is the trunks, so, using a reddish brown pencil and applying a little more pressure, carefully follow their contours and block them in.

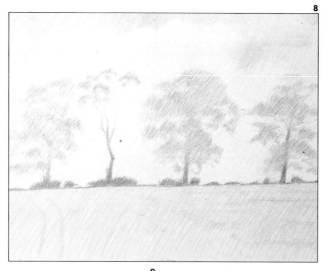

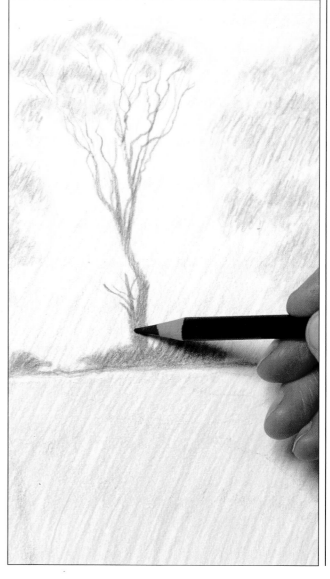

9 Before you attempt any further work on the branches and foliage of the trees, it is important to finish off the sky. Take your blue pencil and fill in all the gaps between the clouds, running over the edges of the trees to fill in the white spaces between the leaves. The reason for doing this now is because the outline of the trees has already been established, so the 'sky holes' can be readily identified. In addition, establishing the correct tone of the sky will make it easier to judge the colours and tones of the trees accurately later on.

10 You can now return to the trees once more and begin some more heavily detailed work. With the reddish brown pencil, work over your initial pale guidelines, following the shapes of the branches and adding any extra ones that you feel will bring the trees to life.

11

11 Once you are satisfied with the trees, the lower half of your picture will need some working up to finish it off and to balance it with the upper half. Taking the purple pencil, pick out the tufts of stubble in the field and run over the track again to give it some definition. Changing to a darkish yellow, shade over the whole area, slowly darkening the tone as you move from left to right across the drawing by gradually applying more pressure on the pencil. This will prevent the field from looking flat and unnatural, as well as adding interest to the overall drawing.

12 The drawing is now complete. In this case the artist felt that the trees required a little more definition, so he quickly worked over the foliage again with green and purple pencils. It is fine to do some small-scale 'tinkering' to your drawing if you feel that any areas need extra definition, but take care not to overdo this as you then run the risk of over-working the picture and ruining the result.

This project demonstrates the value of using a gentle touch with the pencil to build up delicate masses of line and tone that deepen and add interest to the drawing.

12

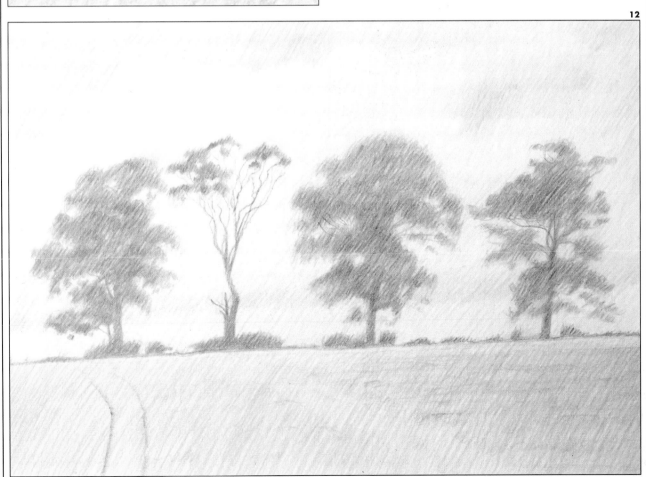

Fields of Tuscany

PASTEL

The reference for this step by step project is a small acrylic painting which the artist did while on holiday in Tuscany, Italy. It is a very quick little painting, done on hardboard, of a small farm surrounded by fields of grapevines.

When it comes to working in pastel, especially the hand-made, extra fat ones used here, such a 'tight' composition is unsuitable. The aim of this project is to show you how to loosen up a scene – be it from life, a photograph, or as here an earlier painting – to suit the bolder, freehand style that is so easy to achieve with pastels. In addition, because the original painting is such an accurate representation of the view, the colour scheme is predominantly green. Since you are going to be rendering this version in a loose, impressionistic way, the predominance of green could slightly deaden the finished picture, therefore the reference picture will be used as a compositional guide only.

It is possible to sharpen the tips of your pastels and use them in a similar way to coloured pencils for a very tightly organized drawing; but half the fun of pastels is that you can use bold, sweeping strokes and blend colours together once on the paper. The best pastel drawings are often those that employ a loose, sketchy style, and the velvety texture of this medium is a delight to work with.

The best way to approach working in pastels is not to give yourself any steadfast rules. You will find that often your best drawings will be the ones that take you the least amount of time, as then your drawing style will be relaxed and confident. If you push yourself into drawing in a style which does not feel comfortable, then this will come across in the finished picture. Follow the step-by-step instructions here, but do not feel that you must obey them to the letter. If you want to change anything or treat a step in a different way, then by all means do so. This way, rather than working hard at learning how to use pastels, the pastels will start to work hard for you.

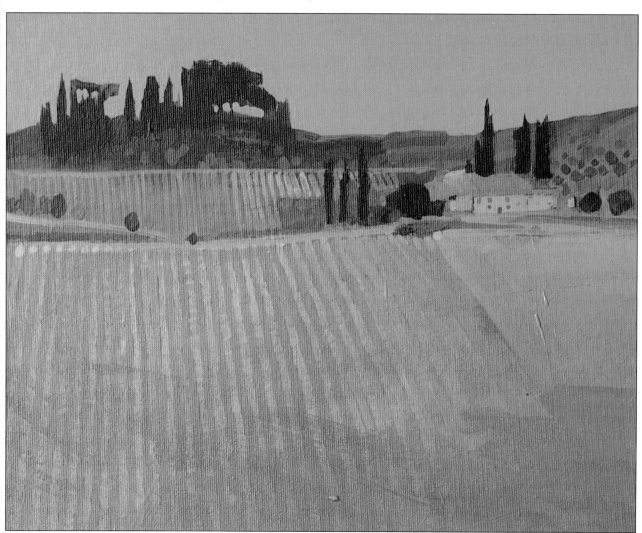

1 Start by blocking in the sky with a medium blue to produce a skyline and the outline of trees on the horizon. When depicting a landscape of this nature in pastels, often the best support to use is a heavy green paper as it can be allowed to show through the overlaid strokes and add harmony and unity to the picture. Obviously this is not a hard-and-fast rule, since different landscapes require a different base colour, but it is sensible to stock up on green papers as they are bound to be the most frequently used.

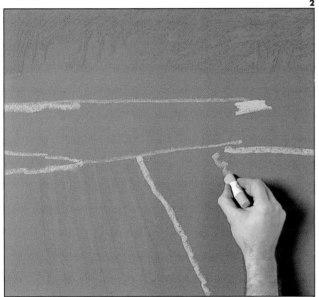

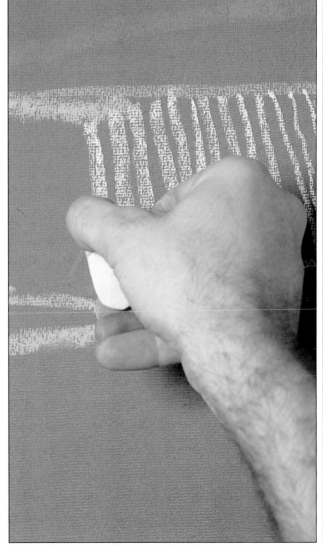

2 It is important to map out the various elements of the composition as early as possible to prevent you getting 'lost' later on and to stop you from getting the nasty shock of finding out you simply have not left enough room for the whole scene. Do this with bold, heavy strokes in only a few colours. Since this drawing is going to be more colourful than the original, make sure you lay down some bright tones early on to clarify this in your mind.

3 Gently outline the various bushes and trees with a light green. Keep the lines faint at this stage as you will be going back over these areas later. Then, using the end of a pale yellow stick, mark in bands down the central field to suggest the furrows running along it.

4 Now go back to the trees on the horizon and start blocking them in with a dark green. Keep your strokes loose, making sure you do not allow the colour to become a solid slab which would be out of character with the rest of the picture. Note how the artist is holding his hand well away from the paper as he works; pastel smudges very easily, so it pays to be careful.

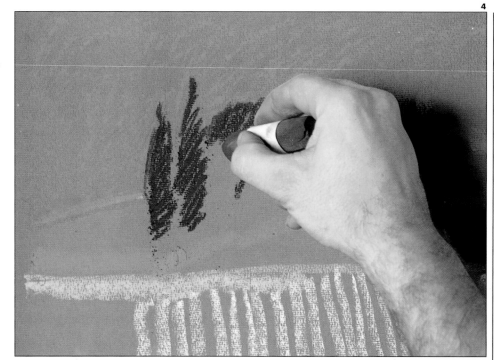

5 Continue blocking in the trees along the skyline, then move down to the ones in the centre of the picture. Use varying shades of green to denote different tree types and to give a sense of light and shade. Most pastel pictures are built up in a very random way, with the artist rapidly switching from one part of the picture to another, trying different colours and techniques as he or she goes. This approach is especially suitable for a loose, impressionistic picture such as this, so if you find yourself embroiled in one small section and getting nowhere, then leave it, tackle something else and go back to it later.

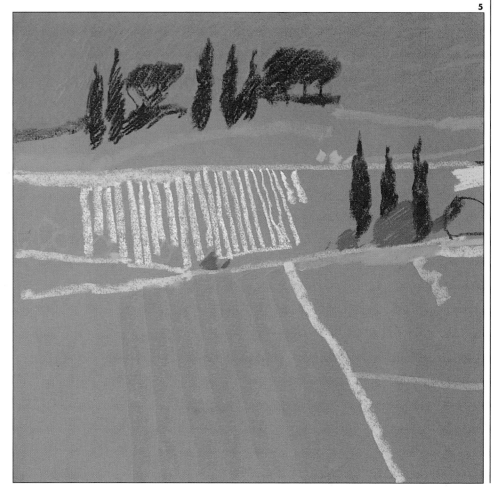

6 Using the side of the stick, block in the field at the front right with a flesh tone. Then go back over it with stripes of light brown using the point of the stick. If you wished, you could then blend these two colours together with your finger to create a pleasant enough effect, but in this case leave it because we shall be going back to it later on for something much better.

7 Continue by using several different green sticks to fill in the fields towards the back of the picture. This will create an attractive patchwork effect which is typical of farmed land. Now that much of the paper is covered, it is time to spray the whole picture with fixative. There are three reasons for doing this; it will darken down the colours slightly, prevent smudging, and, most importantly, allow you to add further layers of colour without muddying the ones underneath.

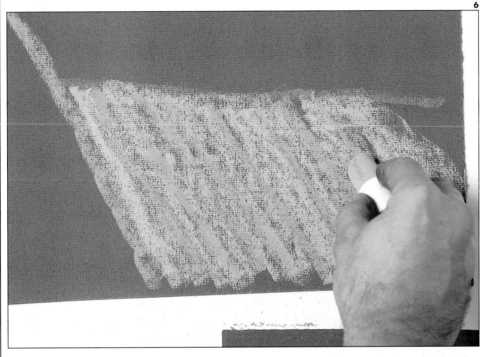

6

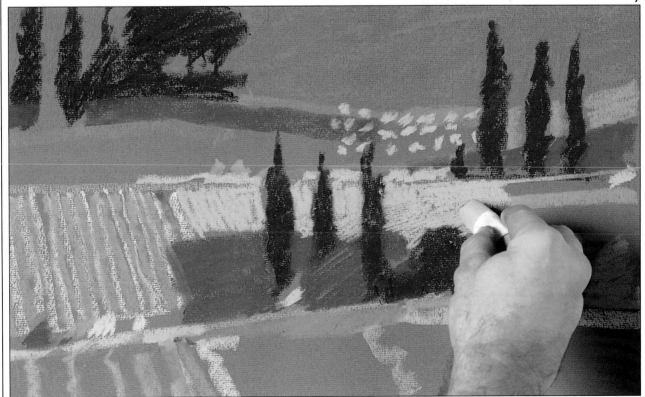

7

8 Now that all the base colours have been fixed, you can start to work up the field of flowers at the front. Use a light pink to fill in the gaps left earlier between the stripes of dark red, and then, using the side of the stick, gently cover the whole field with a thin layer of purple. This will give you a very pleasant undulation of colour which can be further enhanced by adding bands of orange over the top with quick zig-zag marks.

8

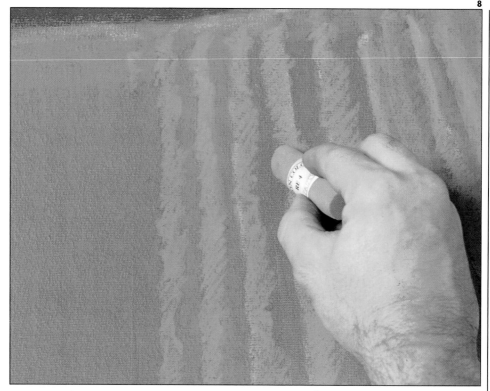

9

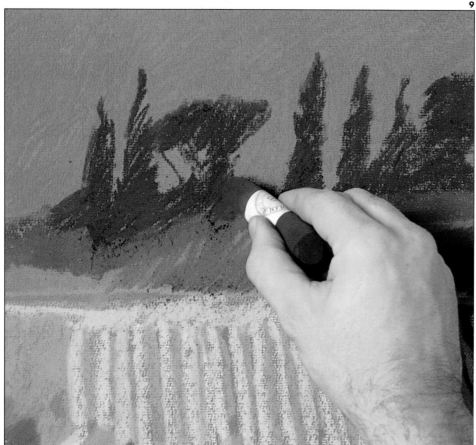

9 Use some lime green to fill in any gaps in the mid-ground, and then switch to the trees on the horizon. This is where the blue sky and the green fields meet, so it is a good idea to introduce a hint of blue into the fields to create a link between the two. This way the sky and land become a united whole, and the landscape has a sense of atmosphere. You originally marked the trees in using dark green, so go back to them and strike in some dark blue.

10 At this point the artist decided that his sky was too dark and was therefore darkening down the mood of his picture. Have a look at your own work so far. If the scene is looking like a bright summer's day then your sky is fine, but if it looks like an overcast day then it will require some attention. The solution is simple. Go over the entire sky with a light blue, not forgetting any bits of sky showing through the gaps in the trees. Once you have done this, again spray the picture with fixative.

11 The field second up from the right has not received any attention yet, so quickly block it in with a dark brown, and then add some details over the top in a light green. Now that the paper is completely covered, you can start work on the finishing details. Cover the field at the front right with a scribble of light brown and then spray it with fixative.

12 While the fixative is drying you can finish off the ploughed field in the centre of the picture. Using the side of the stick, lay a dark olive green all over it to neutralize the colour a little, then go over the lines again with light green, this time making them more 'hazy' by putting them in as gentle zig-zags.

10
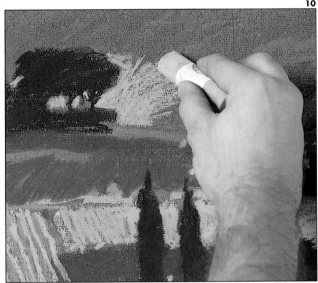

12
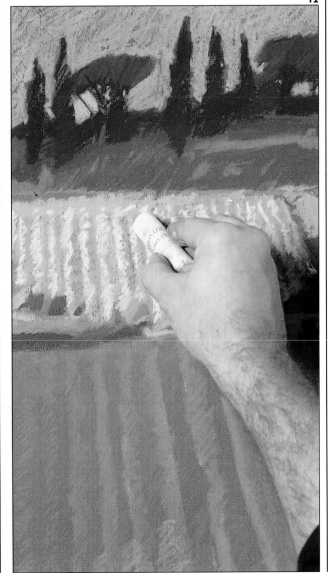

11
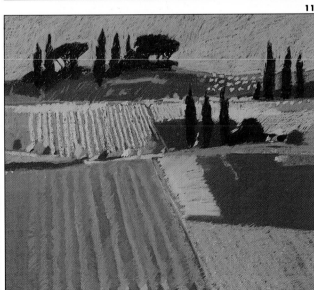

13 The fixative you sprayed on the field at the front will have dried now, so you can return to it for the finishing touches. The fixative was important in this instance to 'set' the colours so that a light shade can be put on top without it blending into the dark tones underneath. So now, using a light skin tone, draw in some furrows down the field, and then to avoid this looking too regimented add some scribbling down one side.

14 The picture is basically made up of browns, greens and the blue of the sky, with the red field at the front to add impact and create an area of contrast which forms the focal point of the composition. The presence of this field can be further enhanced by adding violet zig-zag lines down it so that the viewer's eye will always be drawn to it first.

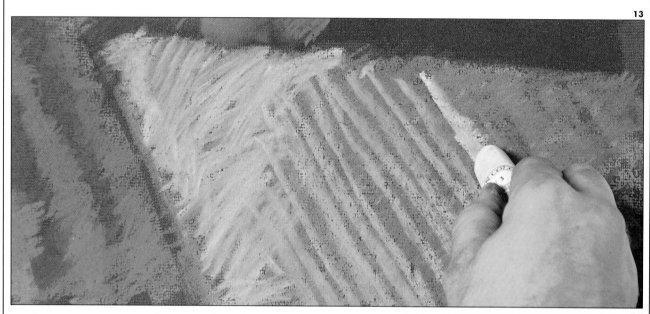

13

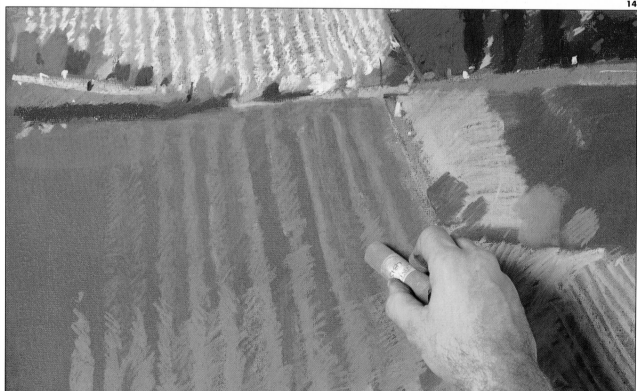

14

15 A final spray of fixative and the picture is completed. In fact in this example the artist decided that although he had lightened the sky once, it was still too dark. Therefore, he simply went back over it with a very light blue. Although it is sometimes worth going back and altering parts of your picture – remembering to always fix the area first – it is often preferable to work quickly and on the spur of the moment. Sometimes a picture can be ruined by going back over the same section again and again looking for perfection. Another important lesson to be learnt from this demonstration is the use of complementary colours in landscapes. The original scene lacked impact because it was all greens and blues, so the artist decided to liven it up by introducing an element of the predominant colour's complementary colour. Complementaries are pairs of pure colour from opposite sides of the colour wheel which, when placed side by side, enhance each other. The complementary of green is red, so the obvious way to liven up this picture was to add a field of red flowers. This is a very blatant example of the rule, but as you can see it does the trick.

15

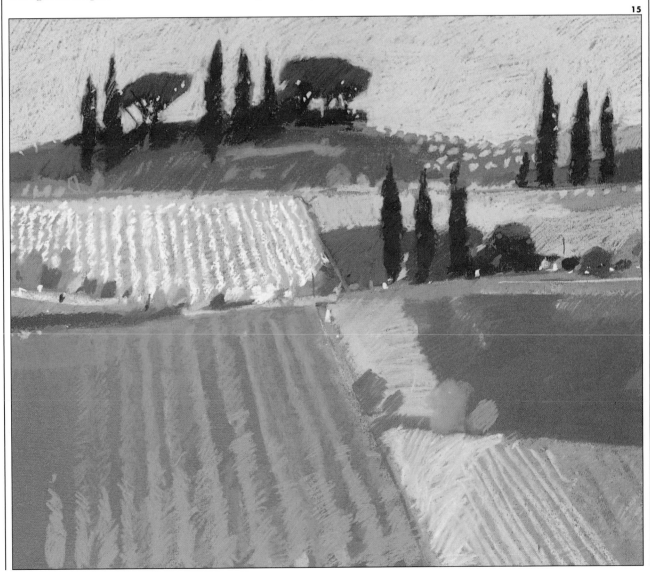

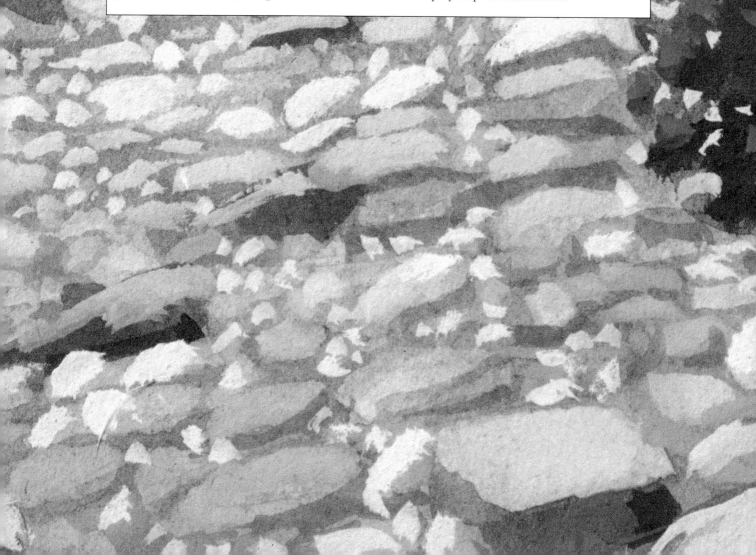

Chapter 5
Watercolour

Watercolour is a favourite with landscape painters throughout the world. It is a highly expressive and versatile medium, perfect for capturing the subtle and ever-changing effects of light on the landscape, the movement of clouds and water or the freshness of spring leaves. On the practical side, watercolours are ideal for painting on location, the materials and equipment being light and easily portable.

Pure watercolour is used for applying thin, translucent washes of colour on white paper. Gouache, an opaque form of watercolour, is perfect for laying flat, opaque patches of colour as well as delicate washes. True, the translucency of pure watercolour is lost, but gouache has the dis-

tinct advantage of allowing the artist to work from dark to light, so enabling them to correct mistakes or add fine details. A very enjoyable approach is to combine both pure watercolour and gouache in a painting and so exploit the best features of both.

Although watercolour has the reputation of being a difficult medium to master, the basic techniques are really very simple. Most beginners fail because they rush into the business of creating a picture without first getting to know how the medium behaves and what it is capable of. Take your time practising the basic techniques at the beginning of this chapter, before moving on to the step-by-step demonstrations.

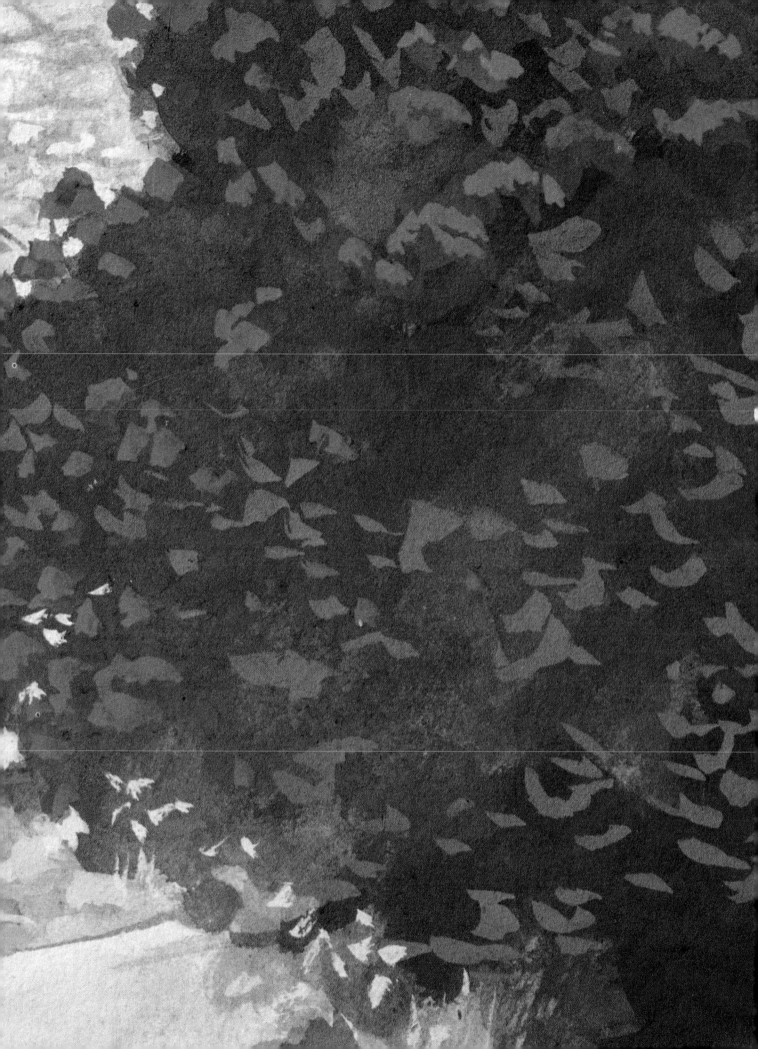

Materials

WATERCOLOUR

Paints

The first decision to make when taking up watercolour painting is whether to go for pure watercolour or gouache. Pure watercolour is available in a variety of different forms, from dry cakes, pans and half pans – which are very small blocks of solid colour – to tubes and bottles of concentrated liquid. Basically it is made from pigment bound with gum arabic. The quality of pure watercolour is reflected in the price: the more you pay, the purer the pigment. It is really only with these pure pigments that you can obtain the brilliance and translucency that makes it such a beautiful medium to work with. Tubes and bottles are very good for laying larger areas of wash, and of course pans are ideal for outdoor work, as they will fit into a box where the open lid can act as your palette.

Gouache is similar to pure watercolour, but contains a proportion of chalk which gives it an opaque quality. As with pure watercolour there are numerous colours to choose from, but since it is so simple to mix colours, only a basic selection is required to get you going.

Palettes

Palettes are available in ceramic, enamelled metal and plastic. Those which contain a row of small recesses with a larger row at the front are the ideal answer for mixing pure watercolour from tubes. The paint is squeezed into the small cavity, and then moved into the larger one to be mixed with water as and when required. Although the ready-bought palettes are very useful, it is always possible to improvise with egg-cups and saucers from the kitchen.

Brushes

Without doubt the best watercolour brushes are red sable, made from the tail of the Siberian mink. Although very expensive, if well cared for, they

will last a lot longer than the cheaper varieties and there will be no problems with moulting hairs. The other types available are made from squirrel – often called camel hair – ox hair, and various synthetic materials. The Chinese hog hair brushes, which are now widely available, are extremely useful as they hold a lot of paint for laying washes but also come to a fine point for painting details.

You will need a good selection of brushes in small, medium and large sizes: flat brushes for laying washes,

round brushes for making expressive strokes, and small brushes for rendering fine details.

Supports

Watercolour paper is available in smooth, medium and rough finishes, and it is worth experimenting to find which type you prefer. Whatever finish you decide to work with, it is always a good idea to invest in high-quality paper for the best results. Light-weight papers need to be stretched before use by soaking them and then securing them to a board to dry. This stops them from buckling when heavy washes are applied.

Techniques

WATERCOLOUR

Laying a Flat Wash

When working in watercolour the most fundamental technique is laying a wash. To practise this, mix some paint and plenty of water in a dish, making sure that you prepare enough to completely cover the area you wish to paint. Load a large brush with colour and lay it on in long, even bands horizontally across the paper, tilting the board towards you so that the colour pools at the bottom edge of each band and can be picked up with the next stroke. When you reach the bottom of the area, pick up any excess paint with a dry brush or small piece of tissue, and allow the wash to dry. Leave the board in the tilted position, otherwise the paint will flow backwards and dry unevenly.

Wet into Wet

When painting in watercolour you do not always have to wait for the paint to dry before laying the next wash. If paint is laid over or next to an area which is still wet, the colours will run into each other and spread, merging to create beautiful soft-edged shapes.

Wet on Dry

Here you can see how very different the effect is when you wait for the wash to dry before laying the next colour. If you want the edges of your coloured areas to be clear and well defined you must always use this technique.

— Laying a Flat Wash —

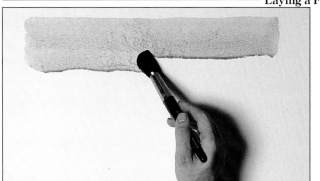
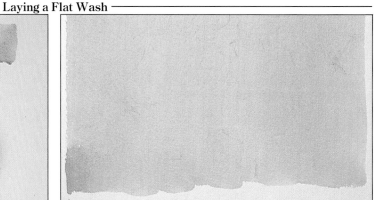

— Wet into Wet —

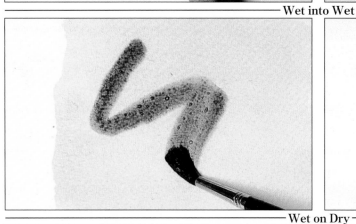
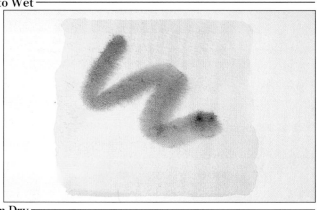

— Wet on Dry —

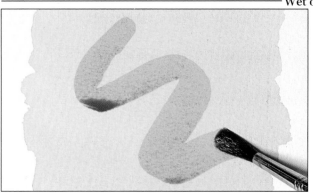
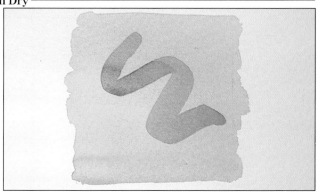

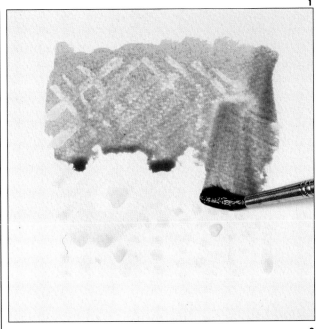

Wash over Masking Fluid

The key to using watercolour is to experiment. Here is a simple technique which was discovered by trial and error, and is perfect for giving an impression of snowflakes in a winter landscape with the minimum of effort.

Using a small brush *(1)*, paint the 'snowflakes' with masking fluid. Allow the masking fluid to dry, and then lay a wash straight over the top. The masking fluid dries to a rubbery, waterproof film which is impervious to water, so it can be painted over without affecting the paper underneath.

Once the wash is completely dry, gently rub the area with your finger *(2)* until all the masking fluid comes off, revealing the white paper below. If you did in fact use this technique on a snow scene then you could paint random dots of masking fluid all over the paper, allow them to dry, and then paint your picture as if they were not there. When the painting was finished and dry, you would go back and rub off the masking fluid to expose the white 'snow flakes'.

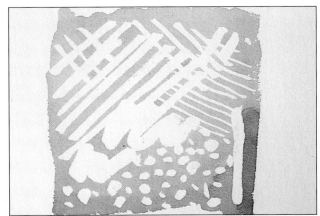

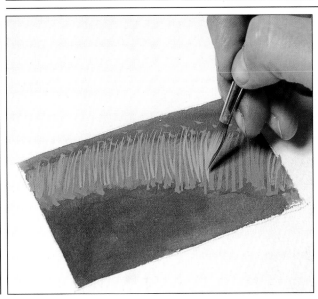

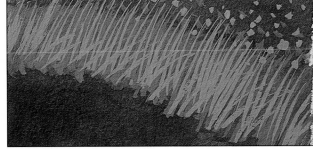

Using Gouache

When working in gouache you have the added advantage of being able to work from dark to light because the paint is opaque. Here two dark green washes are laid, and then linked with a band of medium green while they are still wet. Once this is dry, light strands of grass can be painted over the top in opaque gouache.

Coast of Normandy

PURE WATERCOLOUR

When people refer to watercolour they are normally talking about pure watercolour rather than gouache. This is not an indication of some deep rooted bias towards pure watercolour, but rather a sign of its massive popularity, particularly when it comes to landscape painting.

Almost any scene can be depicted in pure watercolour, but nearly always the most successful are those that utilize its wonderful translucency and play on the effects that can be created with delicate washes. This step-by-step project is just such a case.

The reference is a photograph of the beach and cliffs at Etretat in Normandy, France. The nineteenth-century French painter, Gustave Courbet, painted almost the same scene in 1869. Entitled 'Cliffs at Etretat after the Storm' it demonstrates how the experienced artist's eye can be caught by a scene which will work well as a painting, regardless of where or when they live or the style they choose to paint in.

Pure watercolour landscapes tend to be at their best when depicting 'gentle' scenes with a minimum of detail, so allowing the full use of transparent washes. In this case the artist wanted to capture the scene in all its natural beauty, so he deliberately omitted all the man-made elements such as the wall, boats, buildings and even the people on the beach. Please do not treat this as a rule saying 'always drop anything man-made' as in many cases the inclusion of figures or man-made structures can add much to the interest of a scene. In the case of Courbet's painting, he had included three little fishing boats sitting on the beach, and these do in fact add a great deal of charm to the painting. You will soon learn to use your own judgement and be able to make instinctive decisions on what would look right or wrong depending on what you want to achieve.

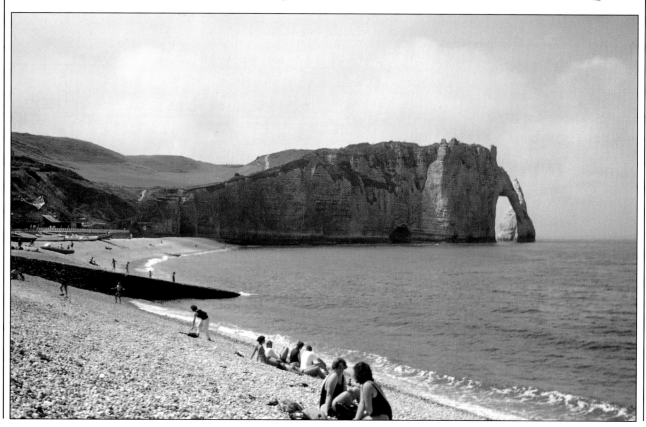

1 Start by making an outline drawing of the scene, keeping the pencil lines as faint as possible because pure watercolour is translucent and will not cover heavy marks. Paint the sky with a pale wash of cobalt blue, leaving areas of white paper exposed to suggest clouds. Use a no. 12 brush to lay the wash quickly, and then switch to a no. 6 brush to cut in around the tops of the hills.

2 When the sky wash is dry – and a hair dryer is always handy to speed things along – the sea is the next area to receive attention. Before laying the wash, tear a rough stencil from heavy watercolour paper and secure it to the bottom edge of the sea area with tape. Mix cobalt blue, Payne's grey and cadmium yellow to create a greeny blue wash and sweep this in quickly. Allow it to dry and then peel off the stencil to reveal the white paper beneath. This will become the edge of a wave as it breaks on the shore.

3 The same colour – with a few drops of gum arabic added – is also used to add texture and movement to the surface of the sea. Gum arabic not only makes the colour more vibrant, it also makes the paint

soluble once dry so that it can be removed (if you make a mistake) or made lighter. This means that you can reverse the normal rule of pure watercolour and work from dark to light. Use a no. 6 brush to add small strokes over the sea's surface. Allow to dry, then wash a small amount of water over the area to 'fog' it up a bit. Finally, put in a few light ripples using the same mix and a small brush.

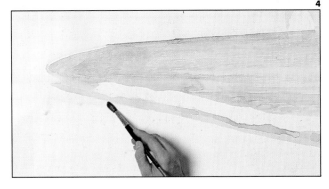

4 Before you can add any textural detail to the cliffs and beach you must first lay a base colour. Create a mix of yellow ochre, sap green and brown madder alizarin, diluted with plenty of water, and cover the whole area with a flat wash.

5 Now mix up some sap green, yellow ochre and raw umber to create a light green for the fields above the cliffs. As you apply the wash, tilt the picture slightly towards you so that the colour lays heavier at the front. Then darken up the mix with a small amount of ivory black and more raw umber, and paint in the sections of fields nearer to the foreground.

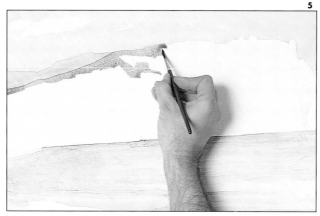

6 Returning to the cliffs, create the illusion of rocks in shadow by applying a wash of Payne's grey, Naples yellow and ivory black over them, overlapping slightly onto the green of the fields to darken it slightly and create the effect of the ground sloping down sharply at the cliff's edge.

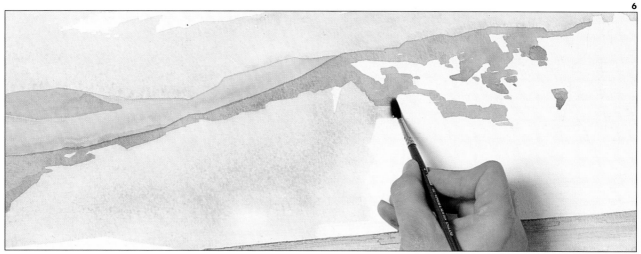

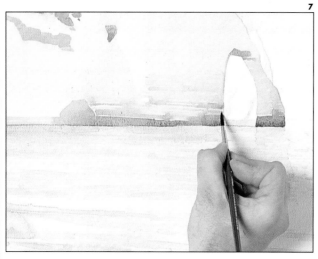

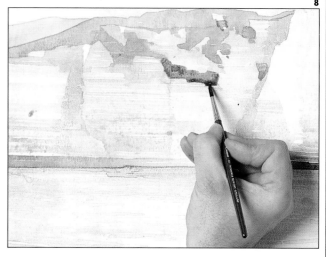

7 Adding textural detail to the cliffs is a long process which should not be rushed. In fact the more time you allow yourself, the better the result will be. The golden rule here is to be patient and allow each wash to dry fully before continuing. Using a no. 6 brush and a mix of yellow ochre and Payne's grey, start by painting in the darkest areas along the base of the cliffs and the couple of small caves.

8 Continuing with the same mix, slowly add in the horizontal bands that run along the cliff face. Do not worry about matching the cliffs in the photograph exactly, since the natural world is so random that any slight differences would only ever be noticed by you. Rest assured everyone else will think you have created a masterpiece!

9

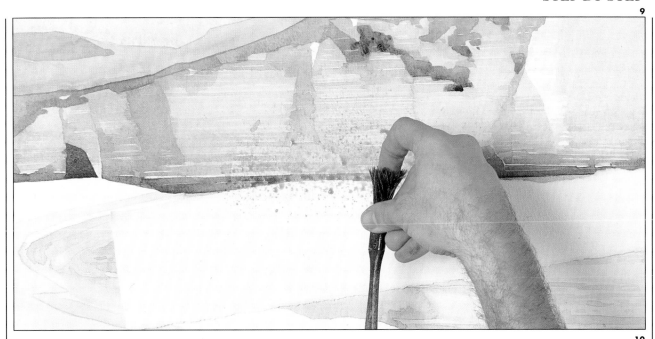

10

9 With the base colours laid down, you can now proceed to add fine detail and texture to the cliffs using a technique called spattering. This involves dipping a stiff bristle brush – or an old toothbrush – into the paint and then flicking it sharply to send a shower of fine droplets onto the paper below. Cover the sea with a torn paper mask to protect it, and then flick on some of the same yellow ochre and Payne's grey mix to create a rough, granular texture. Try to keep most of this along the bottom edge of the cliff as this is the darkest section.

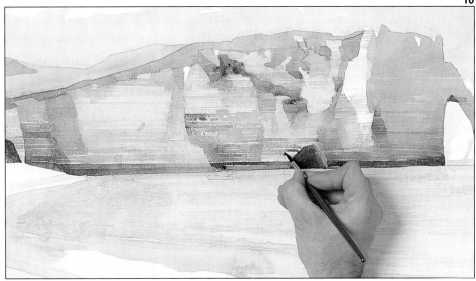

11

10 Make sure the spattering is completely dry. Using the same mix, but this time with less water so that it appears darker, continue building up the planes and surfaces of the cliff face, making some sections of the cliff darker than others to create the illusion of walls of stone at different distances and angles from the viewer. Some are almost entirely in shadow, while others receive a lot of light.

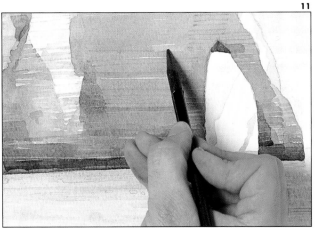

11 When you are satisfied with the result, finish off the cliffs by using a graphite pencil, which has a soft, granular texture, to add some very fine horizontal lines along the cliffs to break up the surface just that little more.

12 Now that the cliffs are finished, they appear to be floating above the sea! What is needed is some reflection of their dark form on the sea's surface. Mix cobalt blue, Payne's grey and cadmium yellow with very little water to make a dark wash, and apply this in small dashes under the darkest areas on the cliffs. This immediately pulls the sea and cliffs back together.

13 At last you can start on the final area of the picture, the beach. Mix up some yellow ochre and brown madder alizarin to create a sandy colour and lay this as a flat wash over the whole of the beach area.

14 Now you are going to use the spattering technique again, this time to paint the pebbles and stones on the beach. Cover up the sea and cliffs with a heavy paper mask to protect

them while you work on the beach area. Mix up some yellow ochre and a little ivory black and flick it over the exposed area using a bristle brush. Try to flick a finer spray at the back with heavier drops towards the foreground to create the illusion of depth. As objects get further away they not only loose their distinction but also appear lighter in colour, hence the finer flicks of paint towards the back.

15 Allow the whole of the beach area to dry (remember the hair dryer if short of time) and then spatter over it again. As you can see in this close up, this very simple technique is an excellent way to add a detailed texture over a large area very quickly. More importantly, it gives a realistic impression of texture without overworking the picture.

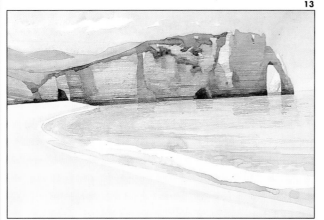

16 Repeat this process several times, using different tones of the same colour to create an impression of light and shade on the pebbles. Here the artist decided to mask the section of beach furthest into the picture and then continued spattering over the foreground.

By putting more colour on to the paper in the foreground than in the background of the picture he creates the illusion of the beach stretching off in to the distance.

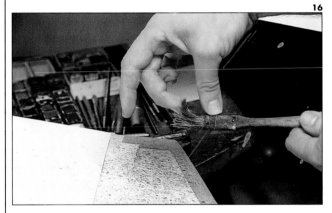

17 The paper mask can be removed to reveal the finished picture. Although i an exact reproduction of the scene, the natural essence has been captured perfectly. Through the contrast of intricate detail on the cliffs and the simple techniques used on the sea and beach, a painting of great depth and character has been created. Note how the eye is drawn up the expanse of the beach, along the cliff face, lingering on items of detail such as the cave mouths, and on to the headland. Whereas in the original photograph the sea appeared to be just a solid slab of blue, in the painting the addition of waves and reflections on the surface has given it life and movement.

Remember there is no rule which says you reproduce exactly what you see; if you feel that you can improve a scene, then by all means give it a go.

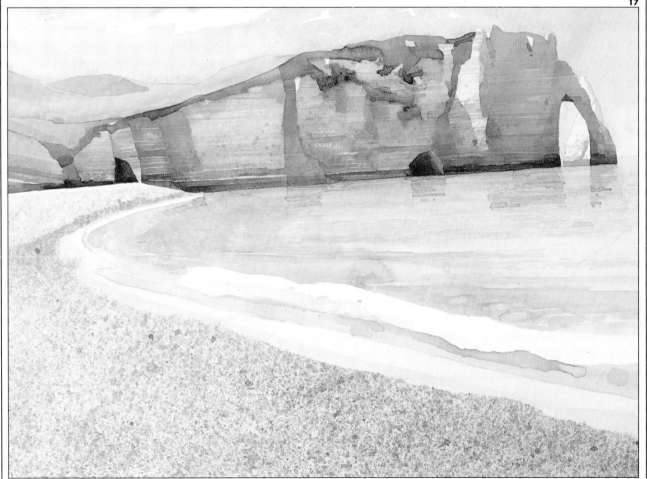

Greek Valley

GOUACHE

One year the artist spent a great deal of time on the Greek island of Ios, where he did several sketches and paintings, and also took numerous photographs to use as reference for paintings once back home. The subject here, based on a photograph, is a dried-up river bed he found while walking in a remote part of the island. It is a charmingly simple scene, enlivened by the profusion of colourful flowers.

The versatility of gouache makes it an ideal choice for this type of subject. It can be applied thinly, to capture some of the transparency of watercolour, or it can be laid as a thick impasto, and because it is opaque you can work light over dark and change the painting as you go.

In contrast to the loose, impressionistic style of some of the paintings in this book, this landscape is more detailed and realistic. Even so, the artist did not slavishly copy the scene but adapted it to suit his own way of working. If you compare the reference shot below to the finished painting on page 97 you can see that the colours have changed slightly and that some of the detail has been lost. But if you were to show the finished painting to a friend without letting them see the original photograph, they would think it very intricate and true to life. This is the trick; you only have to put a certain amount of detail into a painting and people will think they see much more.

When painting a landscape it is very important to choose a medium which is appropriate to the subject and your painting style. The artist chose gouache for this painting because it is more controllable than pure watercolour, allowing him to build up the details slowly. Gouache is often forgotten or ignored in favour of the more 'popular' media, but it has a great deal to offer the artist and is a joy to work with.

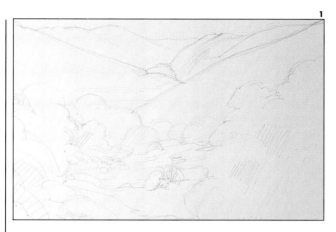

1 The first step is to make an outline drawing with a 2B pencil to map out the composition of the picture. Make only sufficient marks to identify the main colour areas, and resist the temptation to add in too much detail since it will all be painted over eventually.

2 When working in gouache it is often preferable to lay thin washes over all the main colour areas before adding in the details with thicker paint. These initial washes not only provide a base colour which can be picked up later on, but also allow the painter to get a feel for the finished picture early on. The first area to receive attention is the sky. Make a light blue wash with a lot of water, and lay it on with a large wash brush. Hold the picture upside down as the paint dries so that the colour will lay deeper towards the top. This graduation from strong to pale gives an impression of the sky receding towards the horizon.

3 Washes can now be laid over the hills in the distance. Use a blue and orange mix for the ones farthest away and switch to a violet colour (alizarin, Prussian blue and cadmium orange) for the rest. Do not forget to hold the picture upside down as each of these washes dries. You may think that the violet colour over the nearest hills does not match the colour of the real scene at all, but in fact this colour is evident on the small exposed rocks on the right hand side. An important point to remember when laying a base colour wash is always to try to match the lightest tone. In this case you will be able to create the rocks simply by painting the hillside around them. If you had painted the whole area in a dark tone you would have to go back and pick out the rocks with a lighter colour later on.

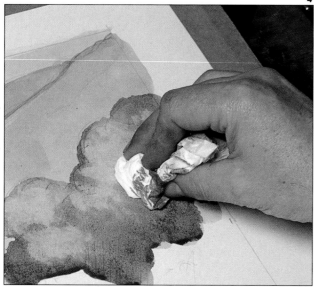

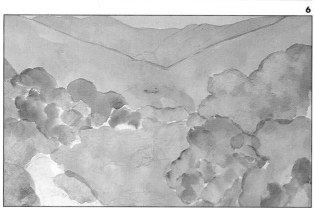

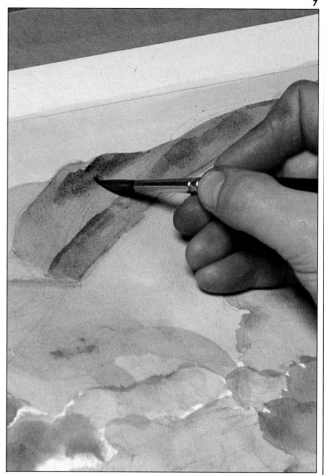

4 You can now suggest the bushes and grass with a mixture of green, cadmium orange and a small amount of cadmium red. Still using a large softhair brush, 'push' the colour onto the paper. This forces the colour out to the edges of the brush and gives a lovely uneven outline – perfect for representing a clump of bushes. To add more texture, blot the paint with a wad of tissue just before it dries.

5 Next dab on some alizarin crimson to the areas where the flowers will be, and again blot with tissue before the colour dries. Continue round the picture marking in the areas where the bushes and flowers will be, and then use a mixture of yellow ochre and cadmium orange to suggest the path at the front left-hand corner.

6 Create a muddy mix of yellow ochre, cadmium orange, Prussian blue and alizarin crimson, and lay it all over the dried-up river bed. While it is still wet drop in some small spots of cadmium orange and then dab the whole area with tissue to create a varied tone and texture. Now that all the base colours are established, allow the picture to dry before moving on to the next stage – using gouache with very little water to build up stronger colours and to add detail.

7 Using a no. 6 round brush, start on the distant hills with a mix of Prussian blue and cadmium orange with just a touch of cadmium red to dirty up the colour slightly. Vary the mix as you go to create the undulations in the hillsides, using not only the original scene as a guide, but also the base colour you laid at the beginning. Because you are now working with very little water in your mixes, you will see that the colour goes on much darker and more opaque.

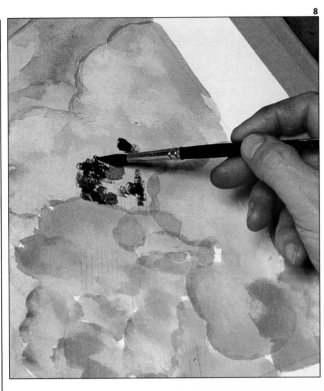

8 Continue by adding a middle brown tone to the hills in front, leaving the area where the rocks will be unpainted for the time being. This whole area will be further darkened later on, so you can quickly paint over in a flat, even tone. Next, apply dashes of dark green to suggest the texture of foliage on the bushes.

9 Once you have added these green dashes to all the darkest areas of the bushes, allow the painting to dry fully. At this point you can see that a convincing sense of depth and distance has been achieved in the background hills. However, the rest of the picture still looks decidedly 'flat'. Try not to worry, it is early days yet!

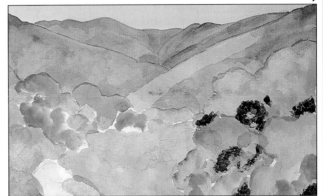

10 Now mix up some cadmium red, Prussian blue and yellow ochre to create a browny grey for painting the shadow areas in the dried-up river bed. Apply the colour as random dashes and blobs all over the area, varying the amount of water in the mixture to create darker and lighter tones. You do not have to be too precise, as this is after all a jumble of rocks and boulders that were left when the river dried up.

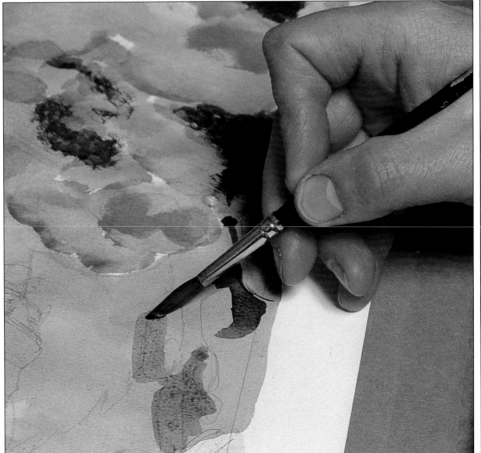

11 Darken more of the bushes with a deep purple/green mix, and then go over the middle-ground hills with an orange-brown mix, including the section you previously left, but leaving gaps for individual rocks.

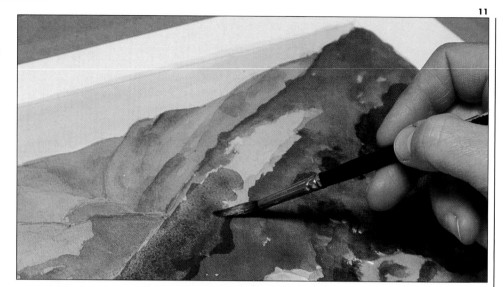

12 While you were painting the hills, the bushes should have dried completely, so you can now return to them. Work dark green into the red areas to define the flower tops. Take your time and make sure that you leave red showing through where the flowers should be.

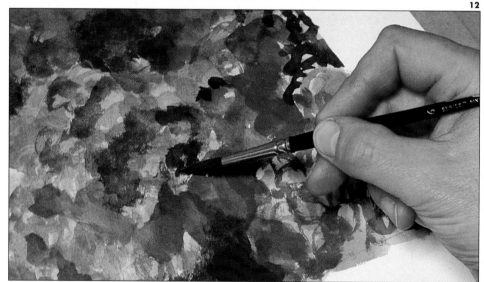

13 The colours in the dried-up river bed may look a little too harsh, as they did in this example, so to overcome this lay a pale wash of cadmium orange all over the area to warm it up a little. Likewise, warm up the colour of the bushes and soften their edges. Use the same orange colour, but make sure that your wash is very pale by adding a lot of water, and then allow the painting to dry.

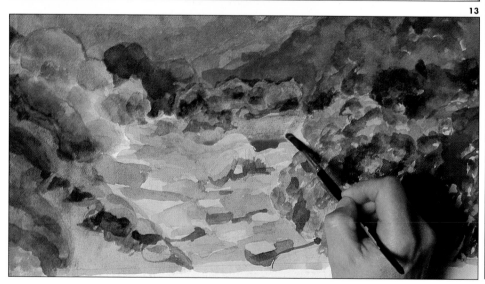

14 You will find that although the orange tint has helped in warming up the colours in the bushes, they still look 'blocky' due to the clash of red and dark green. Mix up a thin wash of medium green and apply it over all the bushes. This softens the harshness of the original colours, and although the area may now look a little 'muddy', you will still be able to see hints of red underneath.

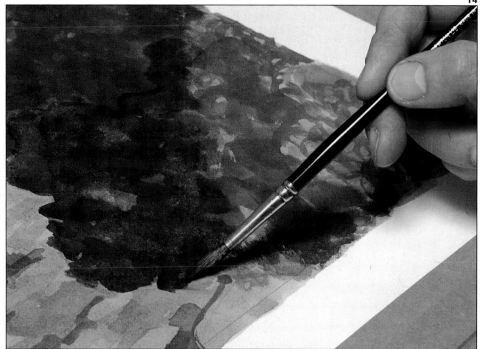

15 Now add a suggestion of rocks and pebbles to the dried-up river bed by putting in some outlines and dark shadows. This gives you a picture which could look almost finished if it were done in pure watercolour, but now the true beauty of gouache can take over. For the rest of the painting you will use gouache with no water added. Without water, gouache is opaque, therefore you can paint light colours over dark ones, something which is usually impossible with pure watercolour.

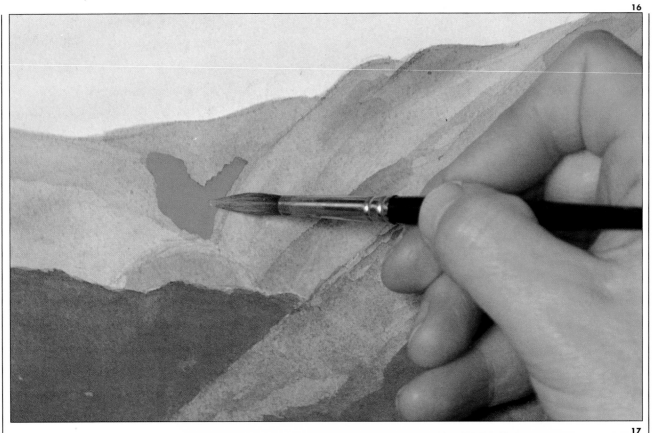

16 Mix up some white, cadmium orange and Prussian blue (with no water!) and start working on the distant hills. You will immediately see how the thick paint sits on top of the original underpainting, and what a completely different texture and look it has. By and large everything you have done so far is for your guidance only. All your original washes should show you exactly where all the overlaid tones and colours should be, and it is now almost a case of simply painting over them with neat gouache.

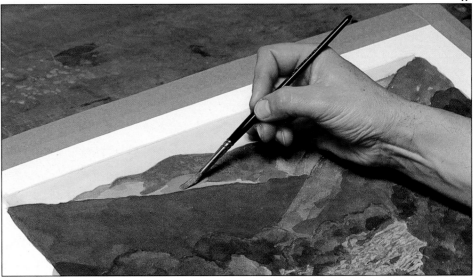

17 Continue working up the background hills, altering your mix of white, cadmium orange and Prussian blue to follow the contours and undulations you established earlier. One thing to note when working in gouache is that it dries slightly lighter than it appears when wet. Take this into account when mixing your colours, but if it does dry much lighter than you expected, then it is a simple case of repainting it until you are happy.

18 Next to receive attention is the hill to the left. This can simply be painted all over in a dark, greeny brown mix. The hill on the right receives the same all over colour, but allow the under-colour to show through here and there to suggest the rocks.

19 Progress is now quite rapid. Once the foreground hills are dry, go back over them with dashes and blobs of dark green to suggest foliage in the distance. Try not to overdo this, since only a suggestion is needed. Small dots of light grey (cadmium orange, Prussian blue, cadmium red and a lot of white) can also be used to pick out some of the stones which you have left. As one part of the picture dries you can easily switch to another, adding details such as the small pile of rocks on the left-hand edge.

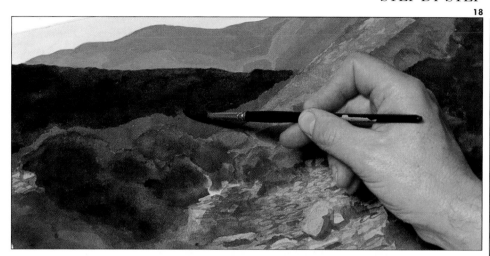

20 Using the same light grey mix, go over the dried-up river bed picking out a few stones here and there. Alter the mix slightly and go over the bed picking out different stones. Continue in this way with three or four different mixes, until all the stones are painted.

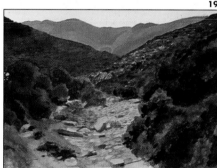

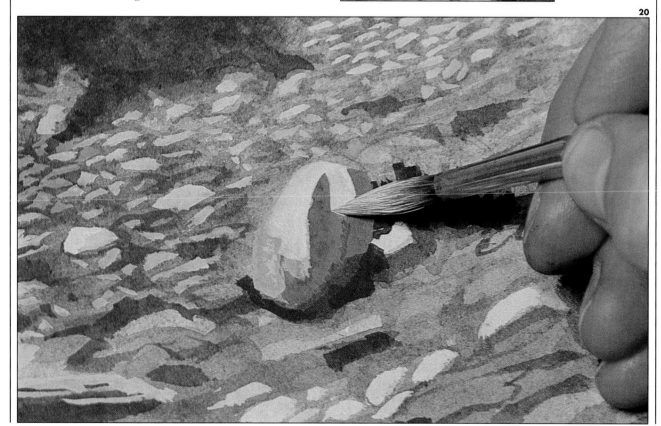

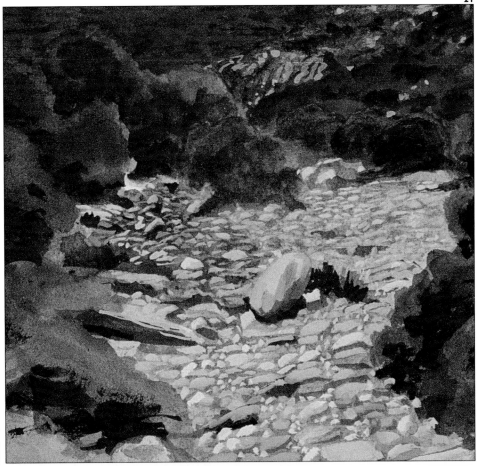

21 At this point the artist realized that the river bed was starting to look like a paved street. If you are having the same problem, do not worry, it is an easy thing to correct. All you need to do is go back and 'tilt' some of the rocks (by making them vertical instead of horizontal) and add in some dabs of grey to suggest smaller stones to rough up the surface.

22 The final details can now be added to your picture. Dab on tiny specks of alizarin crimson mixed with cadmium orange to pick out the flower heads on the bush at the front, and use a slightly lighter tone for the more distant bushes. Likewise, apply tiny dashes of a middle green to the areas where the sun catches the leaves. Then add some yellow ochre to the green to make a lighter mix, and pick out some highlights. Yellow ochre is used to lighten the mix instead of white, since white tends to make colours appear too cool, and also gives a chalky appearance.

23 The area around the path is finished off by adding small dashes of a medium green to denote grass. Lighten this up a little with some yellow ochre, and paint in a few highlights. Finally mix up a browny grey colour and add in a few stones exposed on the path.

24 To complete the picture, dot in a few pale yellow flower heads here and there in the grass, then mix up a light stone colour and put in a few specks along the edge of the bush at the front where it hangs over the dried-up river bed to soften the hard edge.

In effect, you have now painted your picture three times, first with loose washes, then again with much darker tones, and finally with neat gouache to add in all the true tones and detail. This may seem a complicated way to produce a picture, but, as you

can see, the finished result is worth all the effort. Simply by adding specks of colour in the foreground the bushes and shrubs have come alive and appear convincingly detailed, as does the dried-up river bed. In addition the hills at the back have a hazy, distant quality which gives the painting great depth and atmosphere. All of this has in reality been created with a few simple techniques and by allowing enough time to build the picture up slowly.

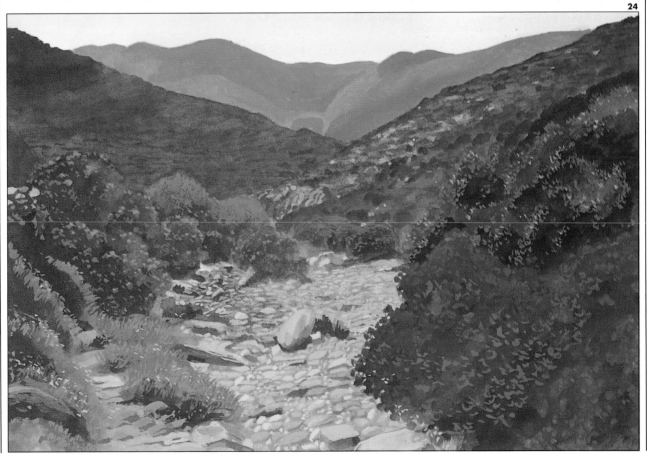

Chapter 6
Acrylics

With the invention of acrylic paints in the 1920s, the first major new painting medium for hundreds of years became available to artists. At the time it was used extensively by mural artists to paint huge propaganda pieces, as, unlike oil paints, it proved extremely resistant to harsh weather and did not discolour with age. In fact, it was not until the late 1950s that acrylics began to be widely used, largely due to their adoption by many of the American 'Pop Art' artists. Bright, brash paintings by the likes of Andy Warhol and Roy Lichstenstein soon gave acrylics a reputation for being extremely colourful, and on their introduction into Europe they were quickly adopted by artists such as David Hockney.

More recently acrylics have tended to be used to mimic the effects of oil paints or watercolours. This is a shame because they have much to offer in their own right – in fact their true limitations are still not really known – and it does seem rather pointless to try and make one medium behave like another.

Because they are so fast-drying, acrylics are ideal for painting landscapes on-the-spot, and you can carry your work home without fear of the paint-smudging. Unfortunately this drying quality used to present problems in hot weather, as the paints hardened on the palette before you even got a chance to use them. Retarders are now readily available to solve this problem.

Materials

ACRYLICS

Paints

Acrylic paints consist of pigments bound in a synthetic resin and suspended in water. Acrylics can be diluted with water, but once they have dried on the support they are water resistant and are probably one of the most hard wearing and permanent of all media.

The choice of colours is vast, with all the traditional hues being readily available, but since they mix so well, a palette of about twelve basic colours is normally more than enough. Like oils, acrylic paints are available in both artists' and students' quality. Cheaper PVA and vinyl paints are also sold especially for use on large areas, but the pigments are of a poorer quality. Artists' quality acrylics will never discolour with age, mix together extremely well, and are so flexible that a painted canvas could be rolled up and the paint would not crack. It is for this reason that some people even use them to paint designs on leather jackets. This versatility is half the fun of using acrylics.

Mediums

There are various acrylic mediums which can be added to the paint to produce different effects. The two main types of medium are those which make the finish more shiny or matt. They both make the paint more transparent and fluid, so are useful when glazing with thin, smooth layers. In addition to these, mediums are available for nearly any effect you can think of. These include ones which increase acrylic's adhesive properties, gels for thickening the paint, right through to retarders which slow the drying time down by several hours.

Supports

Acrylic paint can be used on almost any surface. The only ones to avoid are those which contain wax or oil since the paint will not adhere to such a surface and may peel off once it has dried. For this reason, canvases or boards specifically prepared for oil paints should be avoided.

Canvases primed specially for acrylic paints are available, but a cheaper alternative is hardboard. Depending on your preference, you can choose to paint on either the smooth or the rough side. The surface can be sealed with acrylic medium or, if you prefer a white support, with acrylic gesso.

Brushes

Your choice of brushes will largely depend on the style and techniques that you use. If you tend to use a

watercolour approach, then use watercolour brushes; for an oil approach, use oil painting brushes. Because acrylic paint dries so fast your brushes can be easily destroyed. Be sure to moisten your brushes with water before loading them with acrylic paint, to prevent a gradual build-up that could ruin them. During a painting session, keep your brushes in a jar of water when not in use, so that the paint cannot dry on them – and wash them thoroughly at the end of the session. Most artists find synthetic brushes made of nylon, better for acrylics as they are easier to clean and are cheap enough to replace frequently.

Palettes

Palettes for acrylic painting are made of white plastic, which is easy to clean. Wooden palettes are not recommended as the paint gets into the grain of the wood and is impossible to remove. A special 'Staywet' palette has been developed which keeps the paints wet for days.

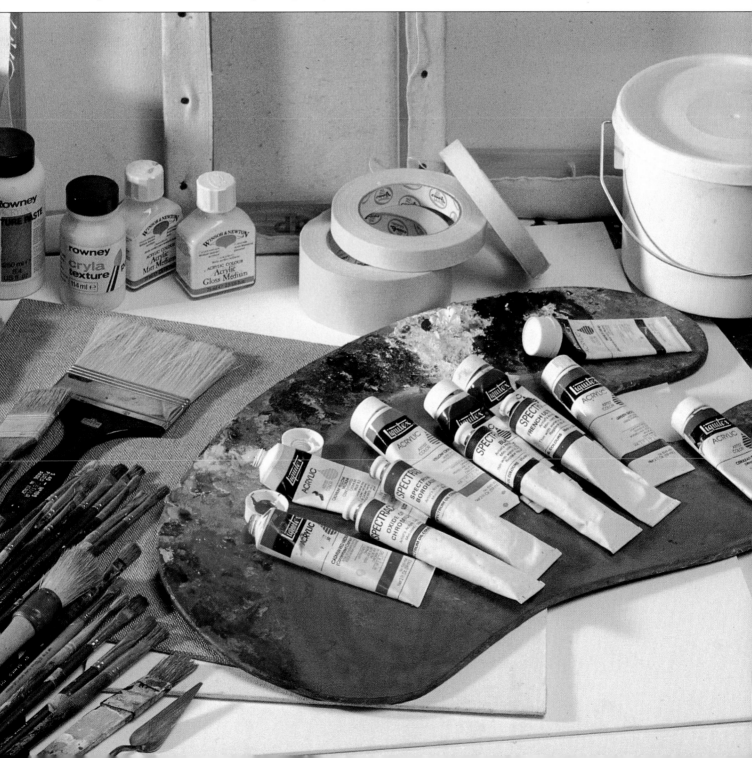

Techniques

ACRYLICS

Glazing

When you add acrylic medium to acrylic paint, it turns transparent and dries to a gloss or semi-gloss finish. This gives you an opportunity to try a kind of optical mixing called glazing. A glaze is a thin layer of transparent colour which is applied over an opaque, dry layer of paint; the glaze combines with the colour below to create a third colour – for example, blue glazed over yellow produces a greenish tint – but the effect is quite different from an equivalent physical mixture of the two colours. This is because the glaze, being transparent, allows light to reflect back off the underlying colour, creating a luminous effect.

Glazing is traditionally associated with oil painting, but acrylics are ideally suited to the technique; unlike oils they dry in minutes, and are insoluble when dry, allowing you to build up several glazes in a short space of time and with no risk of disturbing the underlayers.

To create a sample glaze *(1)*, brush on a few broad bands of colour diluted with just a little water. When this is dry, dilute a second colour to a transparent consistency with acrylic medium and paint a few bands across the base colour, leaving some of it exposed. When the glaze dries, you will see three areas of colour: the two original colours, and an optical mixture where they overlap.

Glazing can be used to enhance layers of thick, heavily textured paint known as impasto *(2)*. The thinned colour settles into the crevices in the paint, accentuating the texture – a useful technique for painting the bark of a tree or a weathered stone wall. Cover a small area with thick paint, allowing the brushstroke texture to remain. When dry, glaze over it with colour thinned with acrylic medium, forcing it into the crevices to expose the peaks.

1

2

Scumbling

Another way of mixing colours optically is by scumbling.. Here opaque or semi-opaque paint is laid unevenly over a dry layer of paint so that only parts of the under-colour are still visible. Lay down a small area of paint, applying it very thickly so that you get a rough, uneven surface. Allow this to dry completely, and then use another colour to lay some random brush marks over the top. The top layer picks up the contours of the paint below, yet still allows it to show through. Scumbling can also be used in a much more subtle way, with the top layer being put on more as a hazy mist to create the effect of a foggy mix of colours.

ACRYLICS

Wet into Wet

Diluted with plenty of water, acrylics can be used in the same way as watercolours yet still retain all the unique properties of the newer medium. To paint wet into wet, brush a coloured wash, well diluted with water, onto the paper. Immediately apply a wash of your second colour next to the first and allow the two colours to meet, blending them slightly with the end of your brush. You will find that adding a little matt or gloss medium to the paint will give you greater control over the washes.

Blending

Because acrylics dry so much faster than oils, subtle graduations and blendings of colour are more difficult to achieve. However, the addition of a little gel medium to the paint gives it a consistency nearer to oil paint and prolongs the drying time.

Another alternative, shown here, is to rough-blend using short, dense strokes. Working quickly, before the paint dries, apply the two colours next to each other and 'knit' them together by stroking and dabbing with your brush at the point where they meet.

Scratching

Any sharp tool can be used to scratch lines into acrylic paint while it is still wet, to create interesting textures and highlights. Experiment with different tools – knives, the end of a brush handle, even your fingernail – to discover the variety of textures and patterns that can be achieved. You can also scratch through a layer of paint to reveal the underlying colour – as the artist has done here to create the impression of sunlit grass.

Lay a base coat of a light-toned green *(1)*, then, while it is still wet, scratch tiny marks all over it with a palette knife. Hold the blade of the knife for maximum control, but do not apply too much pressure as this will damage the surface of your support. Allow to dry, then paint over the entire surface with a slightly darker shade of green.

Again, before the second coat dries, scratch into the surface with your palette knife *(2)* to expose the lighter shades beneath. The finished effect resembles a patch of grass, with some of the longer blades catching the light. This 'grass' effect could be further enhanced by repeating this painting and scratching process, at each stage selecting a slightly darker shade of green.

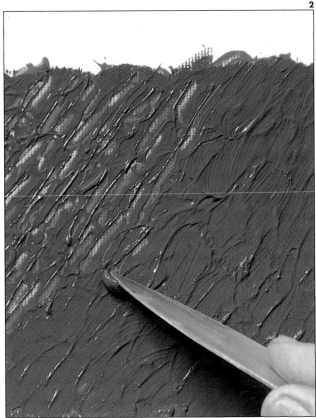

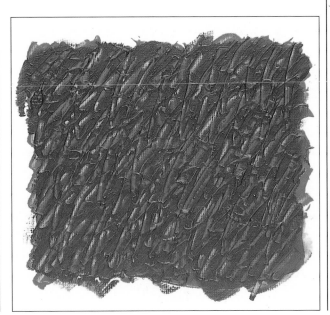

Sunset

ACRYLICS

There were several valid and important reasons for the choice of this subject and the style in which it was rendered. Firstly, landscape painters are not only concerned with the physical elements of a scene, but with the effect of light on those elements. In fact with some artists the play of light has become almost an obsession. This leads us nicely into the impressionistic style chosen for this painting, for it was the Impressionists who based their whole school of thought on their enchantment with light. Therefore we thought it only fitting that we should pay homage to them in a project concerning light, by employing their spontaneous, free technique of working.

The Impressionists never actually worked in acrylics because they had not yet been invented, but we feel sure they would have loved this exciting medium with its bright, vibrant colours and fast-drying properties.

The image was also chosen because it can be broken down into simple bands of colour. This is for your benefit, as this style of painting will take a certain amount of bravery on your part since there is no initial drawing to guide you. Having said that, you could always 'cheat' and at least map out where the bands of colour will fall, but we strongly advise you not to as it will spoil half the fun.

The artist took a series of photographs as the sun was setting. This in turn would be an interesting exercise for rendering a series of paintings recording the changes in the colours of the sky and the quality of the light – something which that great Impressionist, Monet, delighted in doing. As you can see from the two examples below, they make for very different studies.

1 As the style of this picture is loose and impressionistic there is no need to render a detailed pencil drawing first. Using a 1 in (2.5cm) flat brush, lay a dark tone – such as Payne's grey with a little white – to suggest the tree line and the main dark clouds. Do not worry about the brush marks, since these will enhance the lively style of the painting.

2 Now add the band of glowing sunset sky, using a mix of cadmium red, cadmium yellow and titanium white mixed with a little matt medium. This is a useful addition to acrylics as it makes the paint easier to brush on and gives a soft sheen to the colours when dry. If you do not have a proper mixing palette, a sheet of formica or glass will do. A good tip to remember when mixing your paint is not

to mix all the colours together immediately. As in this picture, leave a little of each individual colour on the palette since this enables you to lighten or darken the colour on the canvas as necessary. Block in the sunset colours, again using a 1 in (2.5cm) brush, and mark the position of the sun.

3 Notice that the sunset is not painted as one solid block of colour but with delicate nuances of tone and hue which give a more natural effect. Similarly the area of blue sky is painted with cerulean and titanium white, loosely mixed to give variety and avoid an unnaturally flat effect. The paint is diluted with water and applied in a thin wash over the whole area.

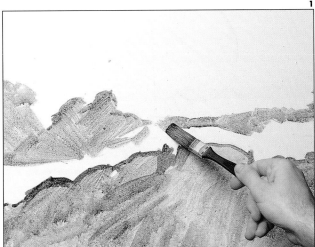

1

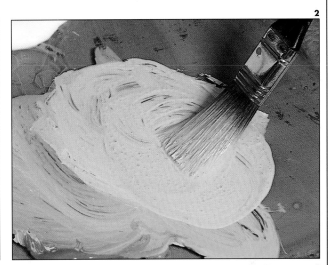

2

3

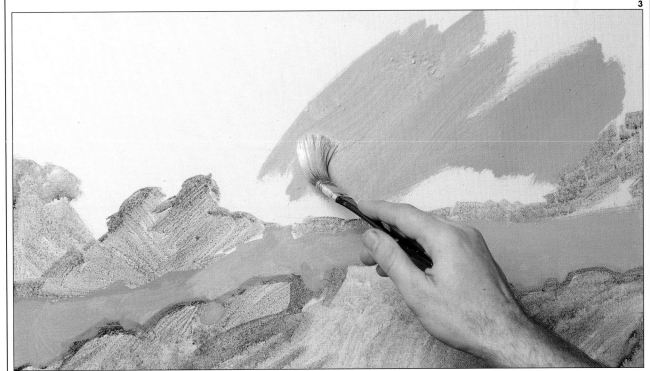

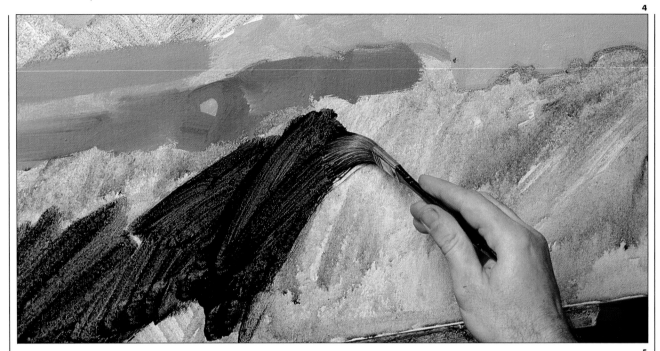

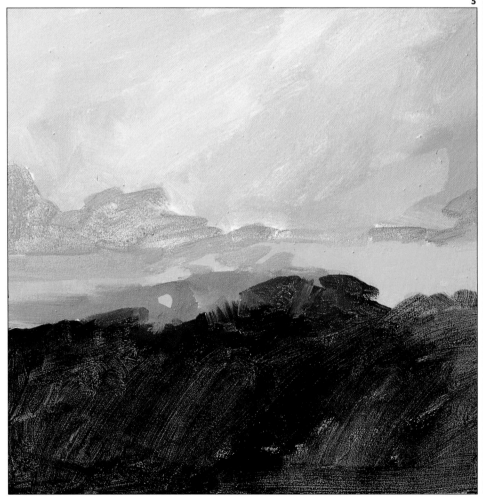

4 In this style of painting there are no rules governing the order of work; you are free to use your own intuition. Note how the artist here has added to the line of glowing sunset on the left simply by darkening his original mix. Using Payne's grey mixed with a little water, darken down the whole of the bottom area of the picture.

5 To your original mix of Payne's grey and white add a little extra Payne's grey, and use it to fill in and darken the very first strokes that you made to suggest the darkest clouds, pulling down slightly onto the band of sunset sky to break up the solid line. At this point your support is pretty much covered and the main elements of your picture are in place, so this it is a good opportunity to take a critical look at the composition as a whole before you go back and focus on specific areas. It is much easier to make any necessary adjustments now, when things are at a relatively simple stage.

6 Switching to a smaller round brush, work up the darker areas of cloud, remembering to keep your strokes fairly loose and including some random dabbing. This will make the line of sunset look pale in comparison, so return to the orange mix used in step 2 and use this to strengthen the colour, changing the tones as you go until you feel happy that the shade is strong enough against the clouds.

7 The rest of the sky can now be completed. Returning to your cerulean and titanium white sky mix, switch back to a 1 in (2.5cm) flat brush and pull the sky into shape, finally adding a wavy line of titanium white to suggest a high ridge of cloud. Still more drama is needed in the storm clouds, so mix Payne's grey, cadmium red, prism violet and white plus some matt medium to achieve a deep, moody shade.

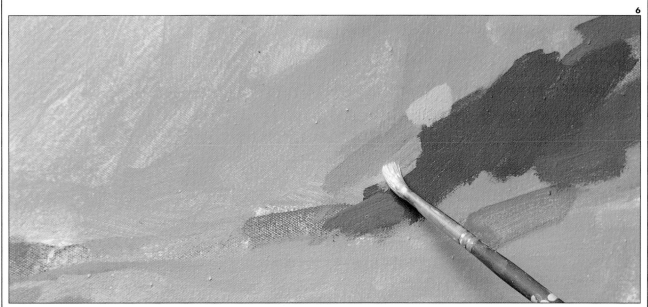

6

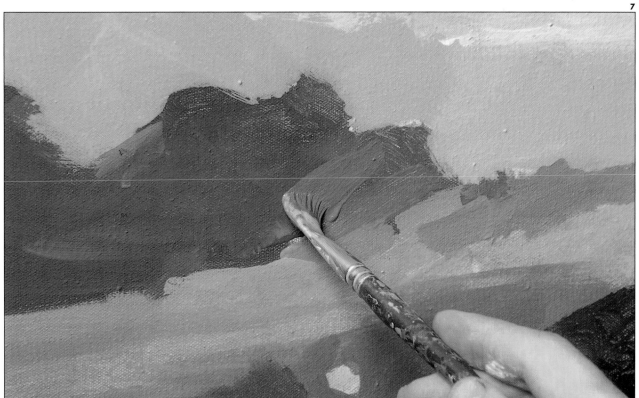

7

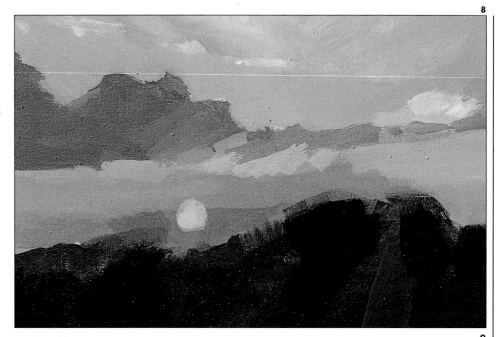

8 You have now completed all the major features of your painting. All that remains are the details, but before you relax just add some cadmium yellow to bring out the brightness of the sun. Now you can really see how it has all pulled together, and should be feeling quite pleased with yourself. It is important to let the whole painting dry fully before embarking on the fine details. Fortunately, with acrylics, this takes only a matter of minutes.

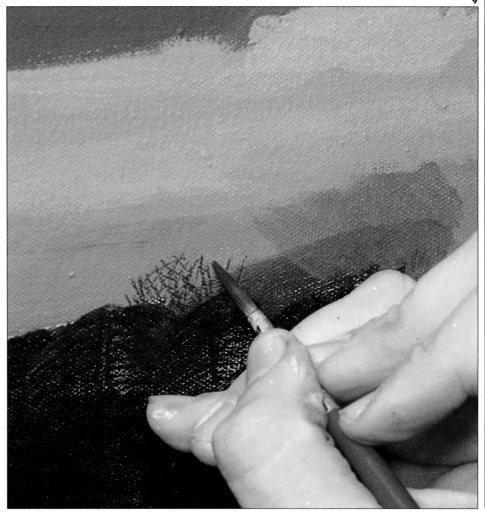

9 Changing to a small, round soft brush and holding it very close to its head for maximum control, use your 'moody' mix (Payne's grey, cadmium red, prism violet, white and some matt medium) with a little ivory black added to very carefully paint in the top branches of the trees. You can see now why it is so important to allow your painting to dry before attempting this, as the side of your hand will be touching the paint surface and would otherwise smudge and ruin all your good work.

10

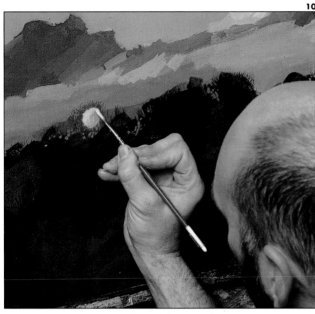

10 Now the painting is almost complete. It just remains to re-paint the sun, making it more solid and bringing it into prominence. You may feel the lower section of the picture looks a bit flat, so in keeping with the impressionistic style, switch to your 1 in (2.5cm) flat brush, add some green to your dark cloud mix and enliven the foreground with some bold, random strokes.

11 Even if your painting does not look exactly like our finished example, we hope this different, loose style of painting has been fun. Step back and ponder on your painting. Note how, although the picture contains very little fine detail, the end result still reflects the original image. In fact the overall feel of this painting is far more moody and atmospheric than the original photograph. As with any painting based on photographic reference, half the fun is in adding your own touches and thereby creating your own personal interpretation.

11

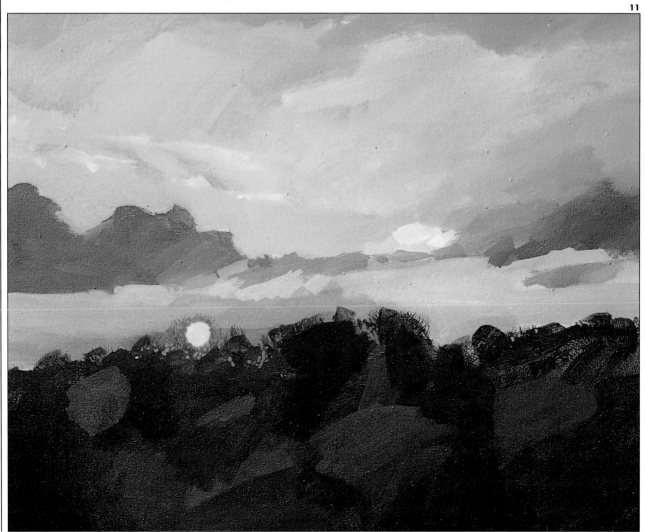

Swiss Alps

ACRYLICS

The original reference on which the following project is based was chosen for several reasons. Although the scene is of great natural beauty, it actually contains a limited range of colours and tones, making it ideal for the novice painter wishing to practise simple colour-mixing techniques. If you have too many colour mixtures on your palette it can become very confusing, because as well as concentrating on getting your painting right, you are also trying to remember which mix was for what and what went into it! However, this does not mean that this project will not present a challenge for any artist at whatever level. It is also a good exercise in creating a harmonious colour scheme by using one basic mixture and adding very few colours to create a limited range of tones and hues.

Another advantage of this image is the simplicity of its line. The scene can easily be broken down into sections, and the drawing itself mainly consists of lines following the contours of the mountains, without involving too many intricate details. This is a huge plus if you are not confident in your drawing ability.

The technique employed in this project is an interesting one, and demonstrates how to build up your painting gradually, allowing for changes or corrections to be made as you go along and for paint mixes to be modified as the work progresses. This in turn allows you more freedom and artistic licence, so take full advantage of this and stamp your work with your own individual mark.

One last point before you embark on this project is that the original reference was on a standard 35mm transparency. Although some people can work perfectly well by holding a transparency up to the light, you may find it easier to use a slide projector, or better still, take the transparency to a local print shop and have a laser copy made. This will not cost much and it is the easiest way of working as the reference will always be there in front of you. In the end however, it is always a matter of personal choice and what best suits you. The main thing is to feel comfortable and enjoy yourself at the same time.

1 Before you embark on a complex scene such as this one it is always a good idea to start off with a pencil drawing. Use a soft pencil such as a 3B which will make a visible mark on the canvas, but is easily rubbed off or painted over. The more accurate you are at this stage, the easier the actual painting will be as you will have all your guidelines laid out in front of you.

2 Making that first stroke with a brush full of colour is always a nerve-racking experience, so here is a nice easy step to start with. Using a round, soft brush and a fairly bright green, lay in the foreground of your painting. This is also a good starting point because this part of the painting is very much a focal point as it is such a contrast to the rest of the scene.

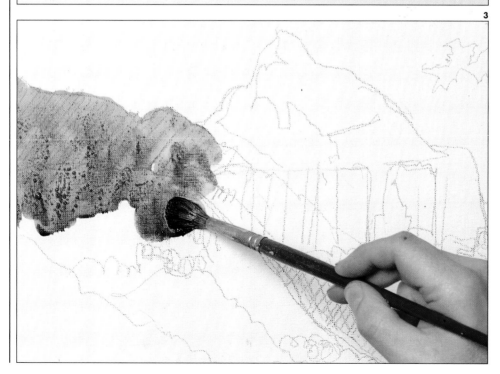

3 The next step is the first layer of paint, which will start to set the colour guidelines and create more of an overall feel to the painting. Start by laying some dark blue mixed with a little water on the left-hand side of the mountain.

4 As you work over this area of mountain, mix a touch of cool red and green into the blue. This makes the colour become slightly muddied. Keep mixing as you go since this will give you an interesting variety of tones. Part of the fun here is not quite knowing how the paint will appear when dry. Note how interesting textures and effects have happened naturally. These will take on their own identity as the painting progresses, later becoming trees on the mountainside.

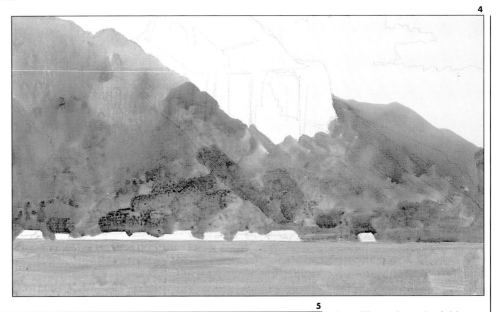

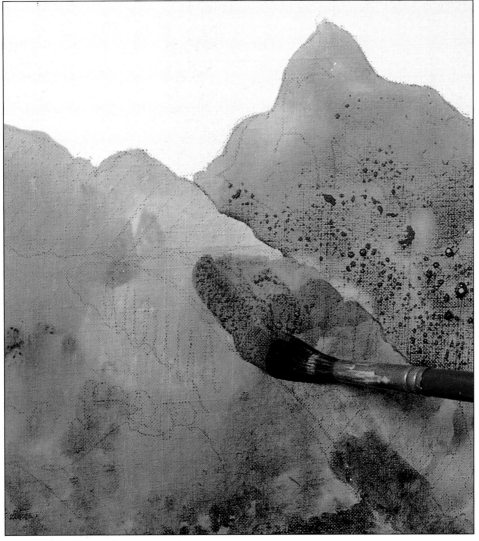

5 The main peak of this mountain needs to stand out from the surrounding area to create a focal point and give the feeling of its great height. Using a mix of blue and red, start filling in this area, increasing the amount of red in the mix as you work down from the pinnacle to the base.

6 You can now reflect on the overall feel of the painting, and perhaps break off for a cup of coffee, while you wait for the first layer of paint to dry. Next, fill in the sky area with some pure blue mixed with a little water, and then proceed to cover the whole of the upper part of the picture, taking the paint right down to meet the green foreground. This will unify all the elements of the painting.

7 While you are waiting for the upper part of the painting to dry, you can complete the foreground. This is where a mahlstick comes in useful, helping to steady your hand when painting small details and preventing accidental smudging of the paint. Rest the padded tip above the canvas and hold the stick with your non-painting hand. Then, supporting your painting hand on the stick, you can paint happily, knowing that you will not smudge any wet paint. To finish the foreground, mix your original green with a little cool red – to keep the continuity of colour going – and fill it in.

8 From this stage on you are going to be adding all the details and finishing touches which will transform the end result. Changing to a small hog bristle brush, which is quite stiff, and with the previous green mix, start painting the buildings at the base of the mountain.

9 Moving upwards with the same brush and mix, work on the areas which will eventually become the trees. The aim at this stage is to establish the form of the mountainside, which will bring that whole area alive. This may sound daunting, but note how your original pencil marks are still visible, providing you with a guideline to follow.

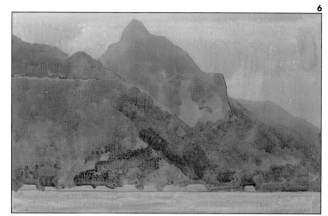

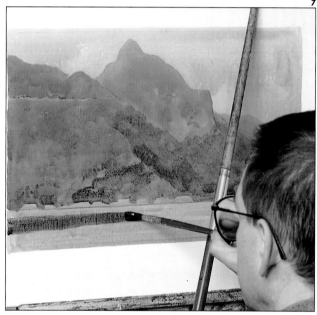

10 The roofs of the buildings are the only details in the picture whose colour is a complete contrast to the rest of the elements. Therefore, to a mix of warm red plus a little orange, add a tiny amount of blue. This may sound strange, but the resulting colour will retain the harmony of the overall painting and stop the roofs from 'screaming out' at you. Use a small soft brush for painting these, as the finish needs to be fairly smooth.

11 There is still a great deal more work to be done to bring out the trees and all the various shades of green. Using the same soft brush, mix some blue and yellow into your green and work over the green areas previously laid. Keep varying the mixture slightly as you go – sometimes adding a little extra blue, then maybe some more yellow – to create a variety of tones and hues which looks more natural than flat colour and enlivens the picture. Here the artist is again using his mahlstick, this time to keep his hand steady while he fills in some small areas around the buildings.

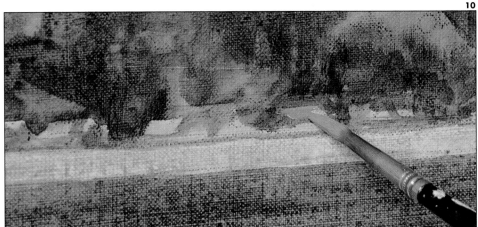

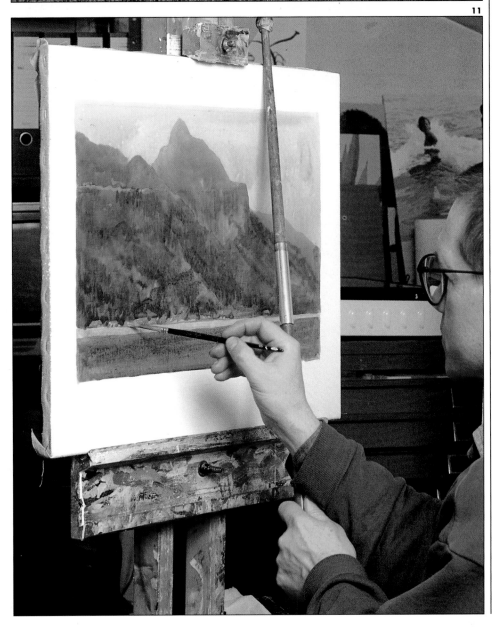

12

12 Working on the left side of your painting, you can now finish off the trees. Mix green paint with a little water to a fairly 'dry' consistency and lightly scumble this across the dark green areas using a flat hog hair brush, making full use of your under-painting by allowing it to show through. (The scumbling technique is explained in more detail on page 103)

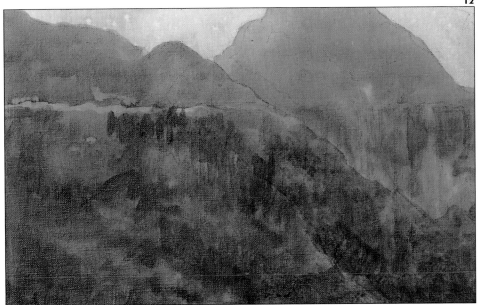

13

13 With the trees complete you can now concentrate on the clouds. You will be using a greyish mix rather than a stark white, since this would make it look too hard and, in addition, the blue would tend to show through a bit too much. Using white as your base, add a little cool red and dark green to create a grey which will be in harmony with the overall painting. Change to a soft brush, and, following your pencil lines, paint in the areas of cloud with uneven strokes to create texture. Once this has dried, lighten the mix with white and paint over the lighter parts of the clouds.

14

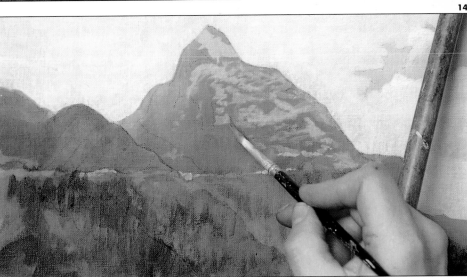

14 Take up your trusty mahlstick once again, not only to avoid smudging the still wet sky, but also to steady your hand while you paint in some small details on the the main peak of the mountain. Into your grey mix add some blue and white, and then, still with a soft brush, carefully paint in the snow caps.

15 You can now stand back and take a good look at your painting. Although it looks finished, there may be some details that require some further work. In this case the artist was not satisfied that he had sufficiently caught the character of the scene and decided to tackle the problem.

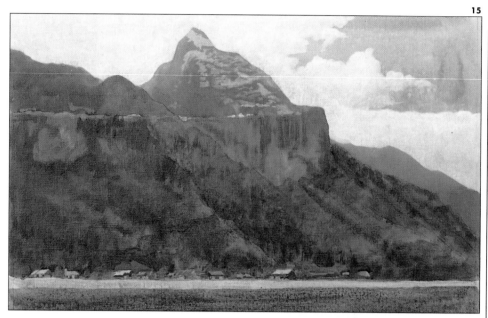

16 The main area the artist was unhappy with was the mountain face, which he felt did not look quite rugged enough. To achieve the required effect, he uses a technique called drybrushing, in which a small amount of almost-neat paint is picked up on the tip of a hog hair brush and dragged lightly over the canvas to leave a rough, broken mark – perfect for a rugged mountain! The colour here is a grey tone mixed from green, blue and red.

17 Although you originally rendered the snow caps in grey to maintain the overall colour harmony of the painting, on reflection they now appear rather dull and muddy. Use the hog hair brush to pick out all the snow caps again, but this time with a pure white. It is much better to experiment with different tones in this way, rather than go for the obvious pure white immediately assuming that it will be right. This also demonstrates the point that colours and tones are affected by those neighbouring them. For example, a colour which looks too dark against the bare canvas may appear much lighter once it is surrounded by other dark colours.

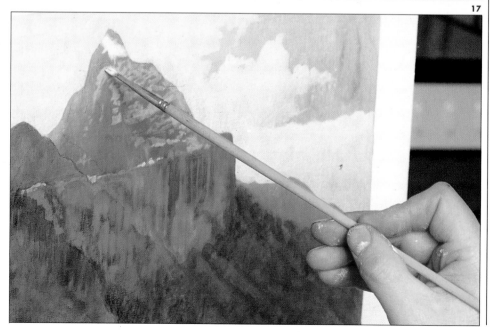

18

18 Finally, after stepping back and comparing his painting to the original scene, the artist realised that there was no definition to any of the trees on the right side of the mountain. Compare your painting to the original reference photograph and you will most likely find the same thing. Switching back to a soft brush, and your green tree mix, lay strokes from top to bottom along the areas which represent the tops of the trees.

19 Here at last the artist was happy – and hopefully you should be too – but it must be said that these last extra touches have made all the difference. The beauty of painting is that it is an ever-changing process; never be afraid to listen to your instincts and make changes and alter elements in a way that suits you. Do not feel that the original reference has to be followed religiously, but use a bit of artistic licence and be willing to experiment. After all, that is what will make your paintings original to you alone. As you progress, you will gain more confidence which will help to develop your own unique style.

19

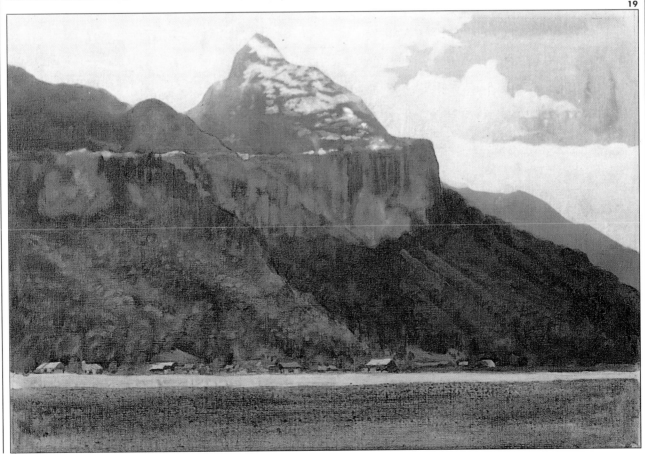

Chapter 7
Oils

Oil paint is perhaps the most popular painting medium of all. This is largely due to its wonderful versatility, allowing virtually any subject to be tackled with a wealth of different techniques at your disposal.

Oil paints were first developed in the early fifteenth century to overcome the problems of working in tempera, the then most common method of painting. Artists wanted a medium which would allow slow, detailed working, give a rich colour quality and generally offer a greater flexibility than tempera allowed. Tempera is still in some limited use today. Powdered colours are mixed with egg yolk to form a mixture which dries in minutes. If you ever come across it and try it out, you will very quickly understand why artists were so desperate to have a new medium to work with.

There are two basic approaches to working with oils. Used straight from the tube they produce a thick, richly textured covering which is perfect for quick impressionistic paintings. Diluted, it can be used to create very thin layers of colour, allowing a painting to be built up exceptionally slowly. From these two fundamental starting points a whole range of different techniques and painting styles can be included to produce a scope of flexibility which is almost limitless. In fact it is very unlikely that once you have taken up oil painting you will ever tire of it.

Materials

OILS

Paints

Oil paints consist of pigments or dyes mixed with a binder such as linseed oil. They are sold ready prepared in tubes, and are available in two grades: students' and artists'. Both are available in a huge range of colours, and although the artists' quality paints contain far superior pigments, the students' paints are perfectly adequate for most purposes. You may find that certain specialized colours are only available in artists' quality paints, but there is no harm in mixing the two types on a painting.

Mediums

Oil paint may be used straight from the tube, but more usually it is thinned with a medium to make it more malleable. The traditional medium is a blend of linseed oil and turpentine, usually in a ratio of 60% oil and 40% turpentine. Be sure to buy purified linseed oil, which dries without yellowing. An alternative to turpentine is white spirit, which is cheaper, has less odour and stores without deteriorating.

Various other mediums are available, all designed to affect the flow, texture and drying rate of the oil paint. For example, beeswax medium (a mixture of beeswax and turpentine) dries slowly and gives a matt finish, while gels (synthetic resins) give extra body to the paint.

Supports

Most oil painting is done on canvas, although wood, card and paper can be used so long as they are properly prepared by sizing and priming. Canvas is ideal as it holds the paint well and provides a sympathetic support, but it is expensive. More suitable for the beginner are prepared canvas boards and paper which are much cheaper. In fact you can buy a special oil paper in pads with tear-off sheets which lasts for years and has a simulated canvas surface.

Brushes

There are four basic brush shapes used in oil painting; round, flat, bright and filbert. The rounds are the most versatile and it is therefore a good idea to have these in a range of sizes.

Other specialist shapes are available but these are usually only used for one particular effect and can therefore be bought as required. Bristle brushes (made of hog's hair) are the ones most widely used in oil painting as they

hold the paint well and produce interesting marks and textures. Soft brushes (made of sable – very expensive – or synthetic hairs) give much smoother strokes and are useful for detailed work.

Other Equipment

Various other bits and pieces worth collecting include a wooden palette together with dippers for your linseed oil and turpentine, a mahlstick (which is a cane with a soft tip at one end,

used for steadying your arm when doing detailed work), painting and palette knives, and, if your budget can stretch that far, a radial easel.

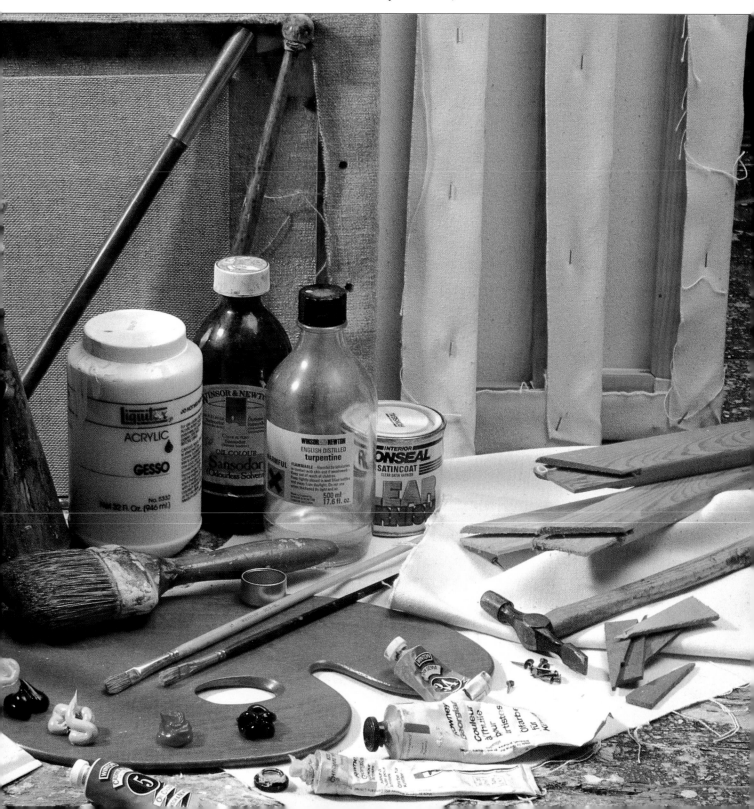

Techniques

OILS

The techniques used when painting in oils are basically the same as those used for acrylics, except that oils, of course, are diluted with linseed oil and turpentine instead of water, and they dry much more slowly than acrylics. Rather than reiterate what has already been said in the Acrylics chapter, we can better utilize the space by concentrating on the different effects that can be produced with various oil painting brushes.

1 1¹/₂ in (3.8cm) flat brush. This brush would normally be used for varnishing a finished painting, but it is also extremely useful for filling in extensive areas of colour in the initial stages of a large painting.

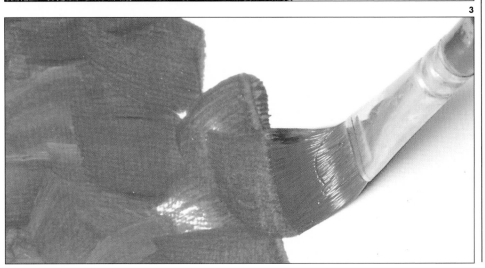

2 ¹/₂ in (1.25cm) flat, bristle brush. This brush is good for applying short dabs of colour, useful in describing form and texture.

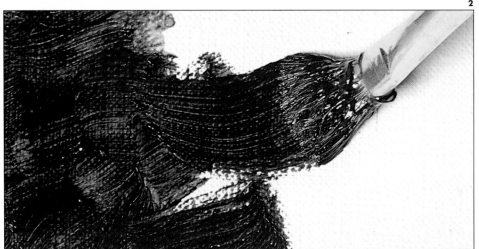

3 ¹/₂ in (1.25cm) flat, softhair brush. Soft brushes are used for subtle blending and for applying thin glazes of colour. Note how different the marks are to those in the previous example.

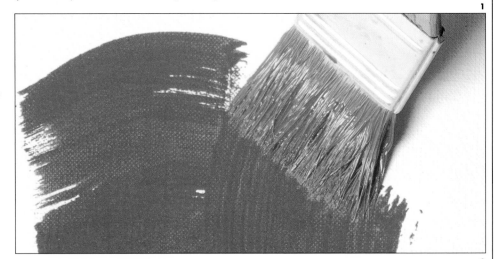

4

4 No. 4 round brush. Not essential, but a useful brush for painting very fine strokes and details.

5

5 $^1/_8$ in (0.3cm) flat, softhair brush. The long bristles of this brush make it sensitive to pressure, allowing you to easily alter the brush mark.

6

6 Large, round bristle brush. This type of brush holds a lot of paint so is good for working loosely and for underpainting.

White Horse

OILS

Here is yet another example of how building up your own library of reference photographs proves so invaluable. While the artist was on holiday in Dorset in southern England, he went out to explore the local countryside and was struck with this beautiful view of rolling fields leading to the hillside on which this famous white horse was carved out of the chalk face in the eighteenth century. It is actually in Osmington near Weymouth and depicts King George III astride his favourite steed. Being a well-prepared artist he immediately pulled out his camera and took some photographs. As a landscape painter you will start to become more aware of your surroundings and find yourself constantly coming across scenes that inspire you to get out your paints immediately. Once you start to view the world in this way, it is even more important not to leave home without your camera and/or sketchbook.

Another advantage of photography is that it is instantaneous. There may be occasions when it is not possible to sketch a scene, still less do a painting of it, either because you have not got the time or because you know the light may change at any second, and this is where a camera proves invaluable. For instance, in this reference photograph you can see how unfriendly the weather can be – it probably poured down with rain half an hour later! Sometimes you will only have the chance to take one shot, but wherever possible do try to shoot the scene from various viewpoints and angles. Not only does this give you a better impression of the scene, but potentially more material to work with back at the studio.

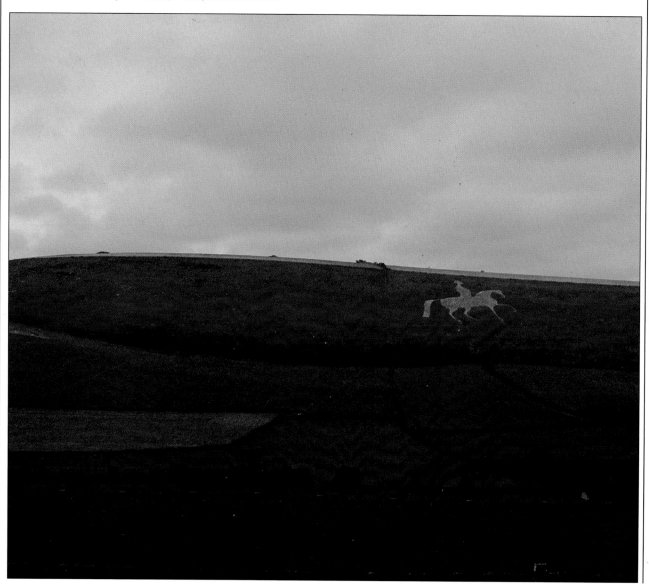

1 Use charcoal or a soft pencil such as a 3B to establish the main lines of the composition. Either of these will make a clear mark without damaging the surface of the canvas, and are easily corrected. Spend some time on this underdrawing because it is important that you are happy with the composition from the outset – and it is far easier to make adjustments now than it is at the painting stage.

2 With some Payne's grey and raw umber thinned down with turpentine and using a $1/8$ in (0.3cm) flat, softhair brush, start to map in the darkest areas of the painting – the hedgerows, trees, fence and the dark mass of the ploughed field in the foreground. This first layer of paint is still part of the planning stage and is just a matter of working up your line drawing and providing a base on which to build up further colours. Allow the paint to dry before moving on to the next stage.

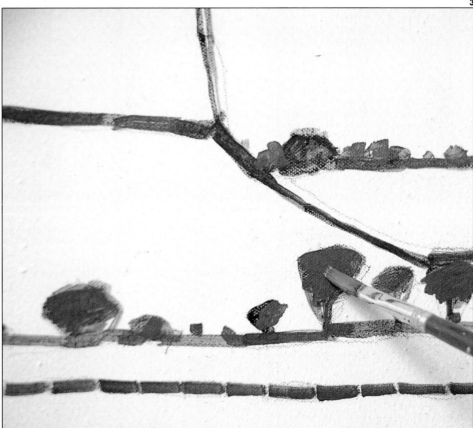

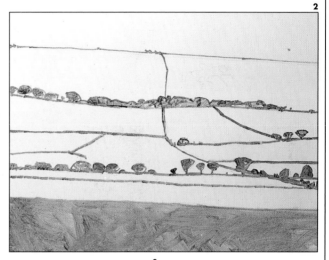

3 In the initial stages of a painting, it is best to concentrate on specific areas of the same colour as this will enable you to achieve a balance between all the elements and to judge the effect of each colour on its neighbour. Using a mixture of raw umber, sap green, Payne's grey, ivory black and yellow ochre, and with the same brush, go over your first layer of paint. This time, however, add much more form and definition.

4 One of the beauties of working in oils is its rich, buttery texture. So make the most of it, even though you are now working on the large, flat areas of the fields, do not apply your colours flatly but use the brush to 'push' the paint around, leaving textural marks that give a sense of the play of light and wind on the grass. With a mix of sap green, raw umber, yellow ochre and a touch of titanium white start to fill in the darker fields and the darkest area of the ploughed field. For these open areas you must switch to a 1/2 in (1.25cm) flat, softhair brush using it to cut in around the horse and all the trees.

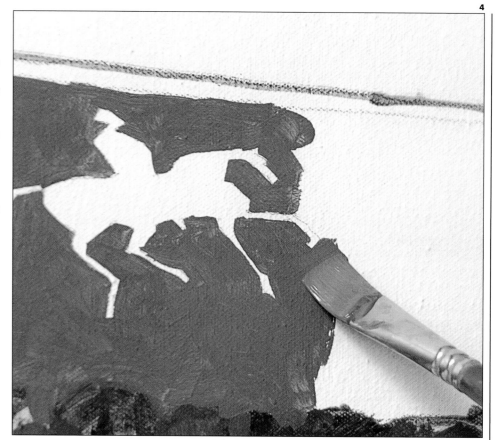

5 Continue to build up the tones and colours in the fields, employing the same free use of the brush, but this time with a lighter mix made up from sap green, yellow ochre, cadmium orange and titanium white. This scene, with its wide open spaces, is ideal for your initial introduction to oils. It not only allows you the freedom to experiment with brush strokes but helps you to become familiar with the medium and its capabilities. Notice how the artist has not been too careful in his depiction of the trees. In fact, where they have hindered the flow of his paint when working on the surrounding fields, he has just painted straight over them! This is obviously done in the knowledge that the trees can easily be painted in again at a later stage.

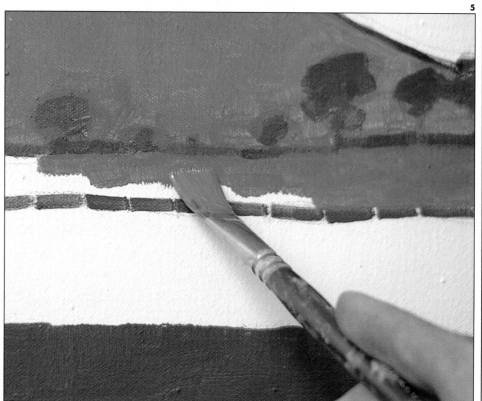

6

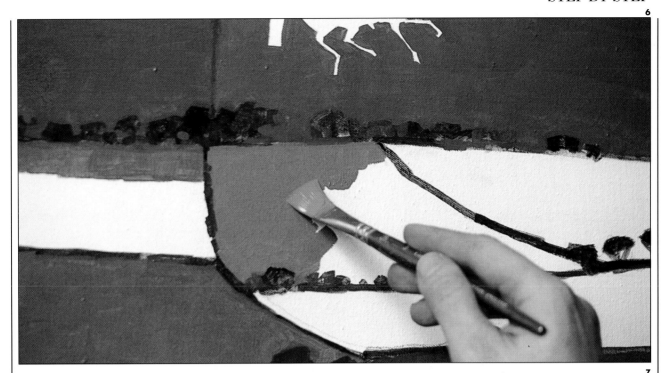

7

6 Now create a slightly lighter green mix by adding some cadmium yellow and titanium white to your previous mix of sap green, yellow ochre, cadmium orange and titanium white. Use this to paint in another couple of fields, then lighten the mix a little more and paint in the remaining fields. Mixing colours additively in this way, rather than mixing a fresh batch each time, ensures that the colours remain harmonious throughout the picture.

7 Lighten this mix once again with yet more cadmium yellow and titanium white to get a very light green, and then use this to carefully paint in a small, light band across the top of the hill, using the tip of the 1/2 in (1.25cm) flat, softhair brush for maximum control. This band of very light colour right on the horizon line will help give the effect of the land rolling over the brink of the hill, catching the sunlight as it does so.

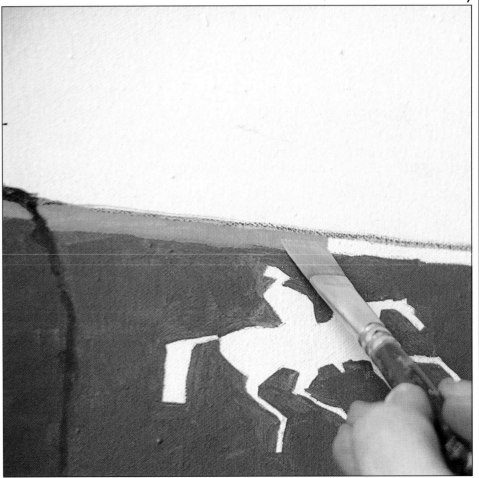

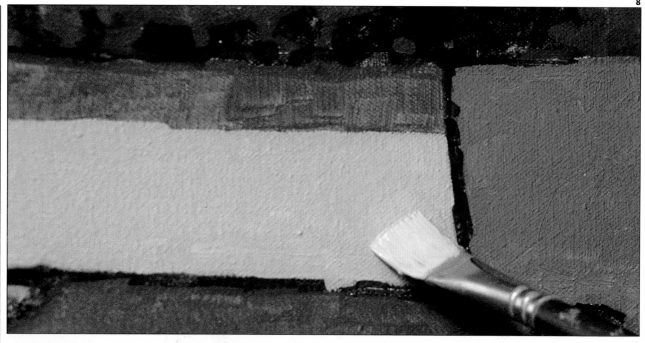

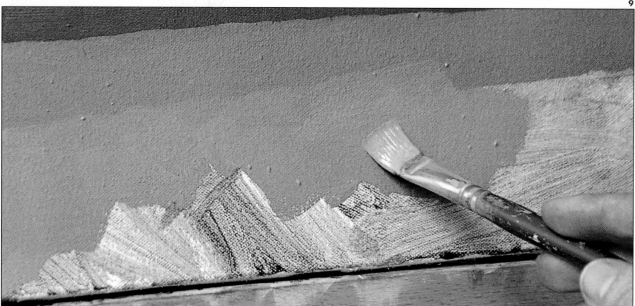

8 At this point in the project the artist stepped back and considered the general composition of the painting. Two prominent areas of light tone – the horse and the light field on the right – have left the picture looking slightly unbalanced. However this is easily corrected by making the large field to the left in the middle distance much lighter by going over it with the same mixture that was used for the light band on the horizon in step 7.

9 The ploughed field in the foreground is the next area requiring attention. Rather than painting this in one flat colour, three distinct bands are to be used to break up the field and add textural and tonal interest. Mix some raw umber, yellow ochre and a little burnt sienna into your light green mix, then divide this into three separate heaps on your palette. Mix some more burnt sienna into one heap to darken it down a little, and add lots of burnt sienna to the second heap to darken it even further. This gives you three distinct tones – light, medium and dark – which are all based on the same colour mix and are therefore in harmony with one another. Lay in these three colours in rough, sweeping bands with your 1/2 in (1.25cm) flat, softhair brush, with the lightest tone at the very front.

10 Leave the painting to dry, and use this opportunity to step back and give your work an overall appraisal. The patchwork of different tones in the fields and the swooping lines of the hedgerows lead the eye inevitably to the focal point of the picture – the white horse on the hill. Since the feeling of depth has now been captured all that remains is to go back and add in the finishing details.

11 Although it is a 'white horse' on the side of the hill, the white of the prepared canvas showing through the paint is far too glaring and is making it look rather like a cut-out. Create a light green/grey mix of raw umber, Payne's grey, titanium white and a little yellow ochre and, using your $1/8$ in (0.3cm) flat, softhair brush, carefully paint in the shape of the horse.

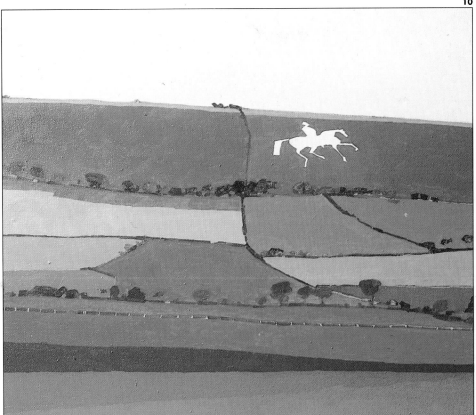

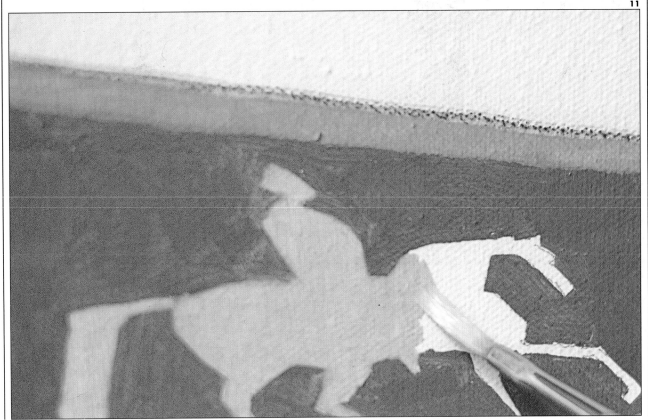

12 Now use this light green/grey mix and the same brush to indicate the fence posts along the dashed band of dark green you laid in right at the beginning. As you can see in the picture here, use the flat end of the brush to lightly dab on these tiny lines of colour one at a time.

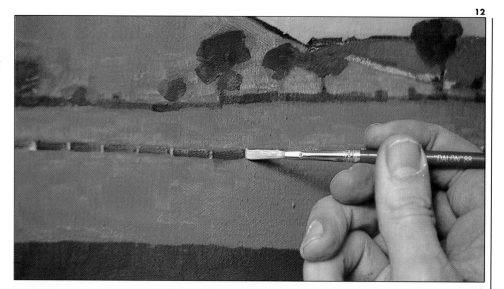

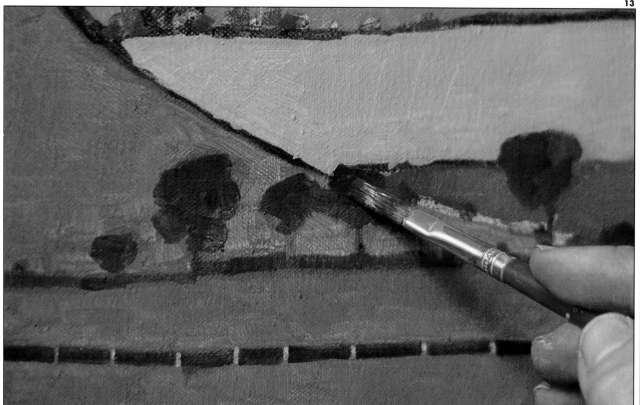

13 The shape and form of the trees will by now have been largely lost due to the painting of the fields around them. Re-create your original dark tree mixture of raw umber, sap green, Payne's grey, ivory black and yellow ochre, and use your 1/8 in (0.3cm) flat, softhair brush to go back and redefine all the trees and bushes throughout the landscape.

14 Nearly all the canvas has now been covered; all that remains is to paint the sky. Start to lay this in with a mix of cobalt blue, white and a hint of Payne's grey. As this is a large area, use a clean 1 in (2.55cm) decorator's brush and work freely and confidently with sweeping strokes. One of the delights of oil painting is that the marks of the brush are an integral part of the painting, adding texture and interest.

15 Congratulations! You have finally completed a painting in what is regarded as one of the most difficult mediums to work in. To help to build up your confidence, take the time to practise and experiment with the techniques before embarking on the project itself. As with most things in life, practise makes perfect, and painting – in whatever medium – is no exception. For instance, if the image you choose to reproduce contains a lot of blues, squeeze some blue paint onto your palette and experiment with the colour, lightening or darkening it and at the same time incorporating other shades that appear in the painting, thereby creating a range of blues that will always be in harmony with the other elements contained within the picture. Work on oil sketching paper or a scrap of canvas and make a note of what went into each mixture. That way, when you come to the actual painting a lot of the hard work has already been done, allowing you to channel your concentration on the painting as opposed to the paint.

Waterfall

OILS

This wonderful, natural scene is going to present you with all sorts of challenges. Just look at the many textures and contrasting elements that are contained within this one image – masses of foliage, tree branches, rocks, foaming water and shimmering reflections. If all this sounds a daunting prospect, rest assured, because the painting can be broken down into a series of steps, and the technique that you are going to employ will make it all possible.

The technique in question has a tradition stretching back centuries. It consists of gradually building up your painting in layers, and increasing the thickness of the paint as you go. This classic style of working up from an underpainting has always been popular, especially during the early Renaissance period when the underpainting was executed in tempera and the oil paint was applied on top.

This slow, considered way of working may be time-consuming, but it has many advantages. Not only does it allow you the freedom to make corrections and alterations as you go, but the build-up of paint layers gives the finished picture a wonderful depth and richness. In addition, where the underpainting is allowed to show through the overlaid colours in places, it helps to tie all the colours together and provides a contrast with the more detailed areas.

Hopefully you are feeling a little more encouraged and are at least ready to have a go. So, prepare that canvas, pick up your brushes and take on the challenge.

1 Because oil paint is opaque you can make a fairly detailed underdrawing without worrying that it will show through the finished painting. So take your time, because if you get this stage right, the rest of the painting will be much easier. Use charcoal or a soft pencil such as a 3B, which will encourage a flowing line, and work from the shoulder as you draw – not the wrist.

2 Once you are satisfied with your initial drawing you can begin painting the darkest areas. Although these may appear black, it is a good idea to mix a little cadmium red and viridian green with your black pigment so as to avoid that solid, flat feel that a pure black seems to give. Dilute the paint with turpentine to a thin consistency and with a flat hog hair brush, attack the canvas!

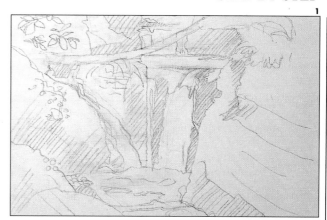

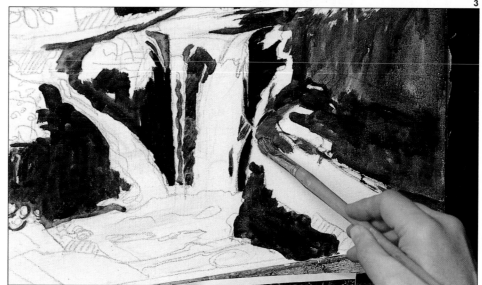

3 Now that all the deepest darks have been established, add some yellow ochre and more cadmium red to your mix to create a dark brownish tone. Using the same brush, start to introduce this lighter mix into the painting, following your initial pencil lines and of course referring back to your original reference.

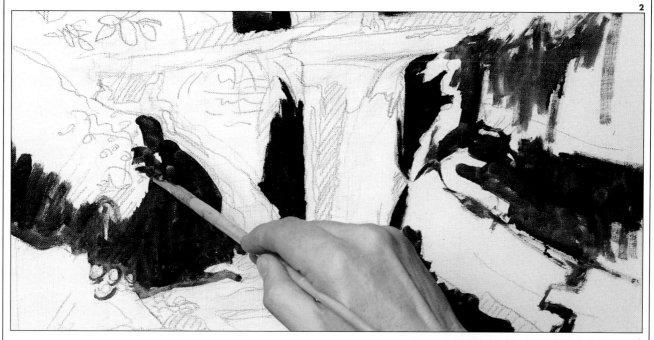

4 Now you can start to introduce some real colour. Part of the fun of working in oils is the actual mixing of the paint, which has such a wonderful, buttery consistency. Treat yourself to a wooden palette, they are not that expensive and even if the painting does not work, you will at least feel like an artist! Add some Prussian blue and viridian green to your previous mix and use this to lay the foundations of the foliage.

5 Continue working over the canvas filling in the areas of foliage with the same mix as before. Note how these tones are already warming and breaking the monotony of what could so easily be a rather monochromatic image. Also bear in mind that this gradual build-up of colour will provide a firm foundation for the details which will be added later. For example, the brown patch on the left will be transformed into foliage by overpainting with smaller strokes and allowing the base colour to show through.

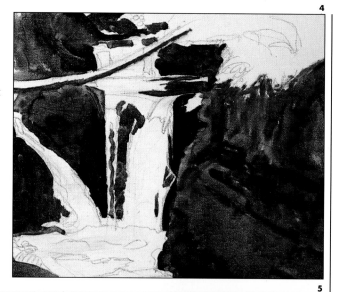

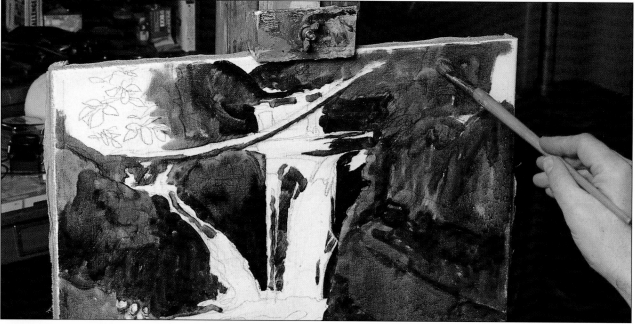

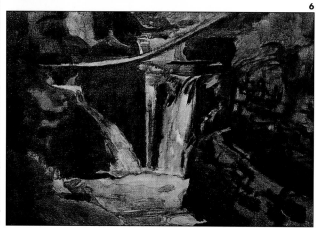

6 The idea now is to completely cover your canvas, laying all the colours that will reflect the general tone of the specific areas. Think about the painting in an almost childlike way and break it down into manageable sections. Leave the water until last, then cover these areas with a new mix of Prussian blue thinned with turpentine. Once you have covered the canvas it is time to stand back and take a critical look at your painting. Are you happy with the overall composition and the arrangement of colours? If not, make any necessary alterations now, while the paint is thin. Then leave the painting to dry.

7 Having made use of this natural break to plot your next move you can start to apply a second layer of paint. This technique of overpainting is a good way of working, particularly for the beginner because it allows you the time to build up the painting slowly – and to build up your confidence at the same time. Using the 'fat over lean' principle, you are now going to work slightly thicker paint, mixed with a little linseed oil as well as turpentine (a ratio of 60% oil and 40% turpentine is about right). Linseed oil makes the paint softer and more malleable, and also slows down the drying time of the paint. Mix some black, cadmium red and viridian green with your oil-and-turpentine thinner, and go over the darkest areas.

8 Keep working into all those darker patches varying the mix slightly as you go to create a lively effect; solid patches of flat colour are deadly dull. As well as creating interest with the colours themselves, make full use of the brush to give movement and textural interest to the paint surface. Now that the paint is being used more thickly, it retains the marks made by the brush, particularly when a hog hair brush is used. Resist the temptation to smooth out the paint – it would be a shame to lose all that wonderful texture!

9 Switch to a smaller flat brush, as you are now going to start work on the left side of the picture, to transform your brown patches into foliage. With the same 'black' mix as before, carefully paint in the outlines of the leaves. They do not have to be perfect leaf shapes, just give a suggestion of form. Now you can see the value of the initial brown underpainting: by allowing it to show through the overlaid strokes of colour, you create an impression of massed foliage without overworking the surface – and save yourself a lot of work into the bargain! Continue upwards, employing the same technique to the green patches above until all the leaves have been finished.

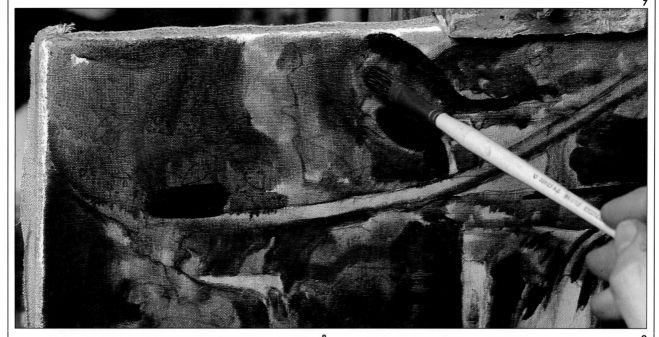

7

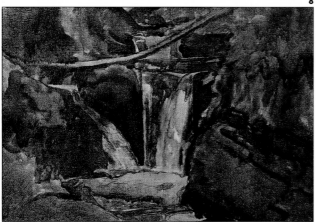

8

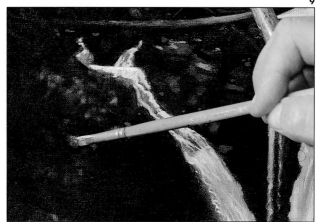

9

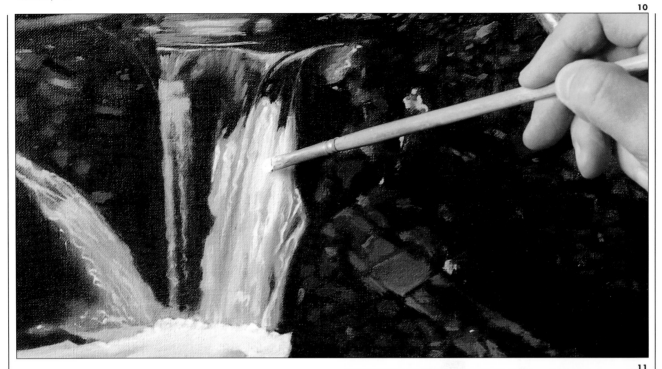

10 For a little relief from all that dark paint, begin working on the waterfall. As this is the focal point of the picture, it really needs to stand out and catch the viewer's eye. With a small flat brush and some pure white mixed to your painting medium, start painting in the falls. Do not totally block in the area, but add 'strips' and slightly wavy lines, allowing some of the blue underlayer to show through. Use a mahlstick to steady your hand and avoid smudging the wet paint. Accentuate where the falls hit the water by using a thicker impasto (more paint, less medium) to suggest the foam.

11 You can now bring out the overhanging branch which stretches across the top of the picture. Although it might seem quite inconsequential, this element is helping to create and add to the spatial depth of the picture. To your original 'black' mix add some Prussian blue and viridian green, plus a little white. Again

using the small brush, and steadying your hand on the mahlstick, paint the branch with smooth, even strokes.

12 Now you are almost there, with just a couple more stages to go. The rocks are your next area of concentration. The main mass of rocks just needs a little more working over, but not too much. For this you will need your 'black' mix once again lightened with some yellow ochre and cadmium red to vary the tone, and the small brush. Once this is complete, lighten the mix with some more yellow ochre and add the pebbles which have caught the light.

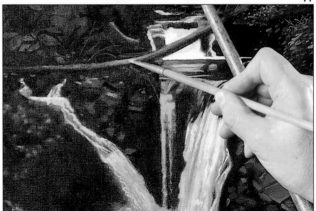

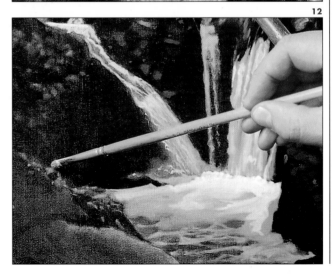

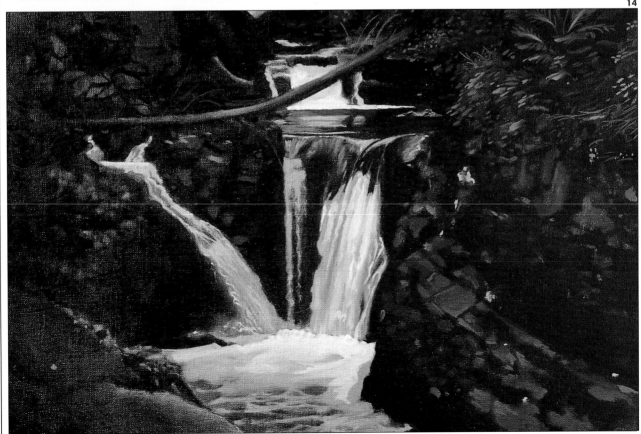

13 Moving over to the top right of your picture, the plants and foliage definitely require a bit of working up to balance them with the rest of the elements, so they do not look neglected. To your previous mix add some viridian green, yellow ochre and a touch of white to create a greenish hue and apply this with a light dabbing motion to represent the leaves. If you prefer to work a little more precisely use a no. 4 softhair brush instead of the hog hair, and hold it near the head, to add the very fine details such as the ferns.

14 Well, this is the moment. You have completed an entire painting in oil! At last you can stand back and admire your efforts. Do not be too critical of your work but enjoy the sense of accomplishment. After all, hopefully, if you have followed this step-by-step project, at the very least you will be standing in front of a canvas with paint on it and it will be all your own work! The idea of all these individual projects is to present you with a challenge and guide you in the right direction. Use them as an initiation, to familiarize yourself with the medium and learn a few 'tricks of the trade'. Then use what you have learned and apply it to your own personal masterpieces.

Index

A

Acrylic 98–119
 blending 104
 brushes 100–101
 canvases 100
 drybrushing 118
 glazing 102
 mediums 100
 optical mixing 101–102
 palettes 101
 scratching 105
 scumbling 103, 117
 Sunset 106–111
 Swiss Alps 112–119
 techniques 102–105
 wet into wet 104
Acrylic gesso 100
Altforfer, Albrecht 14
Atmospheric perspective 27

B

Beeswax medium 122
Bellini, Giovanni 13–14
Blending, acrylic 104
 pastel 60
Bristle brushes 122–123
Bruegel, Peter 14
Brushes, acrylic 100–101
 camel hair 78
 Chinese hog hair 78
 oil 122–123, 124–125
 ox hair 78
 Siberian mink 78
 squirrel 78
 synthetic 78
 watercolour 78
Building up colour, coloured pencil 64
 pastel 58

C

Camel hair brushes 78
Canvas boards and paper 122
Canvases, acrylic 100
 oil 122
Cézanne, Paul 16–17

Charcoal 30–35, 38–45
 Country Lane 38–45
 drawing with 34
 fixative 32, 41, 45
 graded tone 35
 highlights 34
 knocking back 44, 45
 sharpening 32, 43
 soft blending 35
 techniques 34–35
Charcoal pencils 32
Chinese hog hair brushes 78
Choosing a subject 22–23
Claude Lorraine 12–15
Clutch pencils 33
Coast of Normandy 82–87
Coloured pencil 52–57, 62–67
 building up colour 64
 crosshatching 57
 Four Trees 62–67
 loose mixing 56
 optical mixing 56–57
 soft blending 57
 techniques 56–57
Complementary colours 75
Composition 26, 130
Constable, John 14–16
Conté crayons 52
Corot 16
Country Lane 38–45
Courbet, Gustave 15–16, 82
Crosshatching, coloured pencil 57
 graphite pencil 37, 46–51

D

Dali, Salvador 18–19
Degas, Edgar 52
Dippers 123
Drybrushing 118

F

Fat over lean 137
Feathering 60
Fields of Tuscany 68–75
Fixative, charcoal 32, 41, 45
 pastel 71, 74
Four Trees 62–67
Francesca, Piero della 13

G

Gainsborough, Thomas 15
Gels 122
Giger, H R 18–19
Giorgione 13
Glazing 102
Golden section 26–27
Gouache 76–79, 81, 88–97
 Greek Valley 88–97
 techniques 81
Graded tone 35
Graphite pencil 30–33, 36–37, 46–51, 85
 crosshatching 37, 46–51
 hatching 36
 New York's Central Park 46–51
 techniques 36–37
Graphite sticks 33
Greek Valley 88–97
Gum arabic 78, 83

H

Hargreaves, Sally 18–19
Hatching 36
Highlights 34
History of landscape painting 12–19
Hobbema, Meindert 15
Hockney, David 98

I

Impasto 88, 138
Impressionists 16–17, 52, 106

K

Klimt, Gustav 18
Knocking back 44, 45
Koninck, Philips de 15

L

Lead pencil *see* graphite pencil
Lichstenstein, Roy 98
Linear strokes 58
Loose mixing 56
Lorraine, Claude 12–15

M

Magritte 18–19
Mahlstick 115, 123
Masking fluid 81
Materials and equipment
 acrylic 100–101
 charcoal 32
 coloured pencil 54–55
 gouache 78–79
 graphite pencil 33
 oil 122–123
 pastel 54–55
 pure watercolour 78–79
Mediums, acrylic 100
 oil 122
Monet, Claude 16–17, 106

N

Nash, Paul 18
New York's Central Park 46–51

O

Oil 120–139
 fat over lean 137
 mediums 122
 techniques 124–125
 see also Acrylic techniques
 Waterfall 134–139
 White Horse 126–133
Oil pastel 55
Optical mixing *see also* Pointillism
 acrylic 101–102
 coloured pencil 56–57
Ox hair brushes 78

P

Palettes, acrylic 101
 oil 123
 watercolour 78
Papers, as a base colour 69
 Canson 32
 cartridge 47
 Ingres 32, 55
 stretching 79
 watercolour 55, 79

Pastel 52–54, 58–61, 68–75
 blending 60
 building up colour 59
 feathering 60
 Fields of Tuscany 68–75
 fixative 71, 74
 hand–made 68
 linear strokes 58
 oil 55
 pointillism 61
 techniques 58–61
Patenier, Joachim 14
Perspective 27
Photographic film 25
Photographic reference 25, 27, 28–29,
 46, 126
Pissarro, Camille 16–17
Pointillism 60
Pop Art 98
Poussin, Nicolas 14
Pure watercolour 76–81, 82–87
 Coast of Normandy 82–87
 laying a flat wash 80
 spattering 85, 86, 87
 techniques 80–81
 wash over masking fluid 81
 wet into wet 80
 wet on dry 80

R

Radial easels 123
Reformation 14
Rembrandt 15
Renaissance 13, 26, 134
Renoir 16–17
Rococo 15
Rubens, Peter 12–13, 15
Ruisdael, Jacob van 15

S

Scratching 105
Scumbling 103, 117
Seurat, Georges 16–17
Siberian mink brushes 78
Sketchbook 25, 126
Soft blending, charcoal 35
 coloured pencil 57
Spattering 85, 86, 87

Squirrel brushes 78
Staywet palette 101
Studio sticks 52
Sunset 106–111
Supports *see* Papers
Susley, Alfred 16–17
Swiss Alps 112–119
Synthetic brushes 78
Synthetic resins 122

T

Tempera 120
Titian 14
Turner, Joseph Mallord William 14–16

V

Van Gogh, Vincent 16–17
Viewpoint 23
Vinci, Leonardo da 13

W

Warhol, Andy 98
Washes 80–81
Watercolour 76–97
 brushes 78
 techniques 80–81
Waterfall 134–139
Watteau 15
Wax crayons 52
White Horse 126–133
Working from home 24–25
Working outdoors 24–25